10-STEP DRAWING
manga

Brimming with creative inspiration, how-to projects, and useful information to enrich your everyday life, Quarto Knows is a favorite destination for those pursuing their interests and passions. Visit our site and dig deeper with our books into your area of interest: Quarto Creates, Quarto Cooks, Quarto Homes, Quarto Lives, Quarto Drives, Quarto Explores, Quarto Gifts, or Quarto Kids.

Conceived, designed and produced by The Bright Press,
an imprint of Quarto Publishing plc

Publisher: James Evans
Editorial Director: Isheeta Mustafi
Art Director: Katherine Radcliffe
Managing Editor: Jacqui Sayers
Editors: Abbie Sharman and Polly Goodman
Design: JC Lanaway

Printed and bound in China

10-STEP DRAWING
manga

LEARN TO DRAW 30 MANGA
CHARACTERS & ANIMALS IN TEN EASY STEPS!

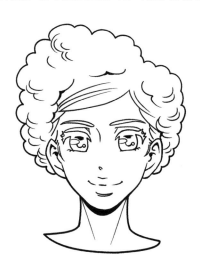

CHIE KUTSUWADA

Contents

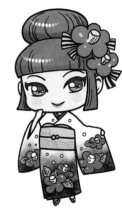

≫ Facial Features

≫ Chibi Style

≫ Manga Faces

≫ Manga Body

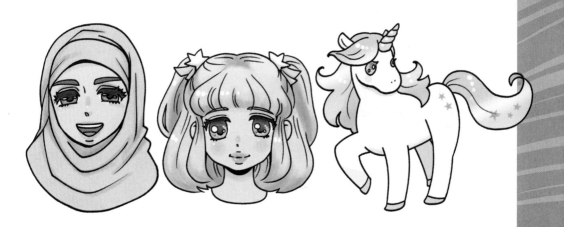

Whole Body Poses

Manga Animals

Characters

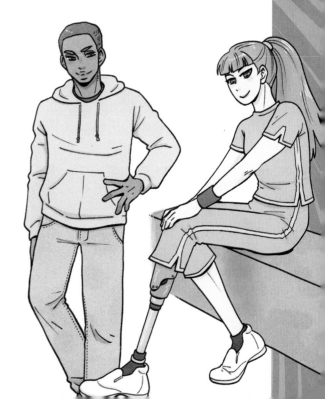

Introduction

In this book, you will find more than 30 manga illustrations of people and animals that have been created in just ten simple steps. Whether it's a chibi princess, a cool manga facial expression, or a colorful unicorn, it's time to choose your favorite image and get drawing.

TACKLING DIFFERENT SHAPES

People and animals come in different shapes and sizes. Each drawing in this book begins with a simple shape or outline to begin. The step-by-step instructions often also advise you to use further circles or other shape outlines as guides for placing heads and limbs. This will enable you to get the proportions of your characters right.

All of the drawings in this book involve lots of different shapes. Following the instructions and guides on which shape each element should be will help you achieve the overall appearance of different people and animals.

I have also provided a color palette at the end of each finished drawing. Use this as a guide, but feel free to experiment and use your favorite shades for makeup and clothing and different colors for the animals' fur.

I hope you will enjoy creating the characters in this book as much as I did. Drawing has never been easier!

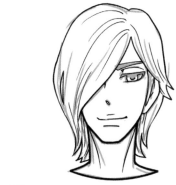

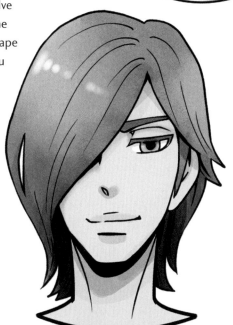

How to use this book

BASIC EQUIPMENT

Paper: any paper will do, but using sketch paper will give you the best results.

Pencil, eraser, and pencil sharpener: try different pencil grades and invest in a good-quality eraser and sharpener.

Pen: for inking the final image. A medium or fine ink pen is best; ink is better than ballpoint because it dries quickly and is less likely to smudge.

Small ruler: this is optional, but you may find it useful for drawing guidelines.

FOLLOWING THE STEPS

Use pencil and follow each step. When you are happy with the image, draw over it in ink and leave it to dry. Then erase the underlying pencil. Finally, apply color as you like.

COLORING

Stay inside the lines and keep your pencils sharp so you have control in the smaller areas.

To achieve a lighter or darker shade, try layering the color or pressing harder with your pencil.

Clothing and animal feathers or fur come in different colors and have different patterns and textures, so once you're confident with where the shading should be, try varying the colors you use.

You have several options when it comes to coloring your drawings—why not explore them all?

Pencils: this is the simplest option, and the one I have chosen for finishing the pictures in this book. A good set of colored pencils, with about 24 shades, is really all you need.

Paint and brush: watercolor is probably easiest to work with for beginners, although using acrylic or oil means that you can paint over any mistakes. You'll need two or three brushes of different sizes, with at least one very fine brush.

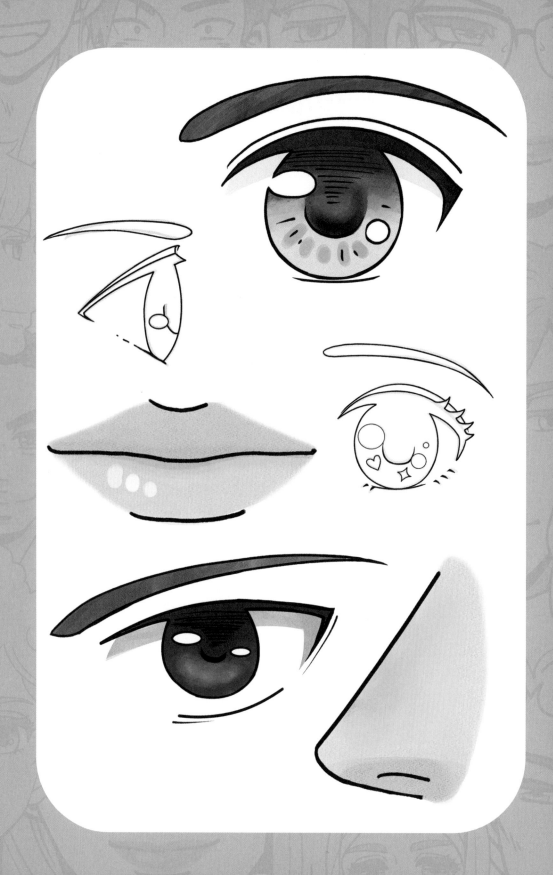

Facial Features

Front
Basic Eye

Eyes are so important when drawing manga—they can convey a huge range of emotions without any dialogue. Follow these steps to become a master!

1. Draw a horizontal, curved line to form the top lid.

2. Draw a circle underneath the line, and add a short curved line beneath.

3. Adjust the shape of the eye by thickening the top lid a little. Add an indication of the pupil in the center.

4. Now think about where the light is coming from. Add a round highlighted part inside the main eye circle. Add a little reflection circle diagonally across from the first highlight.

5. Draw and shape the eyebrow—the most basic type is parallel to and slightly wider than the eye.

Note:
In manga, the right eye and left eye are usually mirror images, but the positions of the highlights are not.

6 Ink your outlines,
making them as
smooth as possible.
Erase the guidelines.

7 Add some detail,
such as shadow
and the iris.

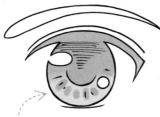

8 Decide on the color of the eye
(see palette below for guidance)
and start with the palest color.
Darken the top part of eye, with
some darker shades on the iris.

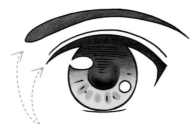

9 Darken the top lid, top part of
the eye, and the pupil. Color the
eyebrow, considering the direction
of the hair.

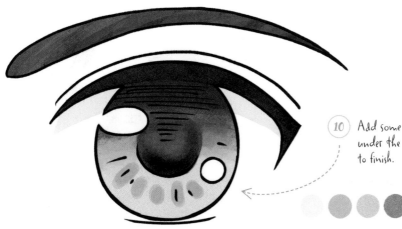

10 Add some shadow
under the top lid
to finish.

Basic Eye

The eye has a very different shape when seen from the side, but once you know the differences, you'll be able to draw it easily.

(1) Draw a sideways V-shape.

(2) Add a curved line, the spherical eyeball, to close up the V-shape.

(3) Add the outline of an iris.

(4) Define the shape of the eye by adding the top lid.

(5) Add an indication of the pupil with a gesture line of its lower half and a highlight beside it. Add a line for a double eyelid.

6 Draw an outline of the eyebrow. Slightly wider than the eye works best — see the arrow to the right of the image for a good balance.

7 Ink your lines to make them as smooth as possible. Erase the guidelines.

8 Start coloring, using the palette below as a guide, building up from the palest color. Shade in some accents on the pupil and iris.

9 Add a darker shade to the pupil and top part of the eye. Color the eyebrow by using brushstrokes, as if tracing each hair.

10 Add some shadow under the top lid to finish.

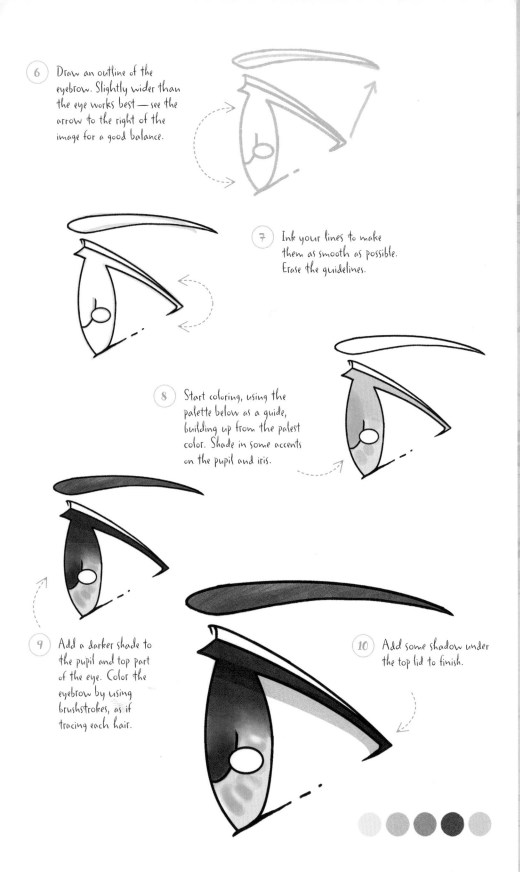

Cute Eye

For a super-cute manga character, use some curly lashes
and add some fun reflection shapes.

1. Draw a horizontal,
sharply curved line,
one side slightly slanted,
for the top lid.

2. Draw a big circle
underneath the line.
Then add a short curved
line beneath.

3. Adjust the shape of the whole eye by
thickening the top lid a little. Indicate
the relatively larger pupil in the center.
Add the double eyelid line.

4. Imagine where the light is coming from. Then
add a slightly oval highlight inside the main
eye circle. Add a little reflection circle, lined up
diagonally with the first highlight.

5. Draw the eyebrow, almost
parallel to the eye but slightly
slanted. Leave some space between
the eye and eyebrow.

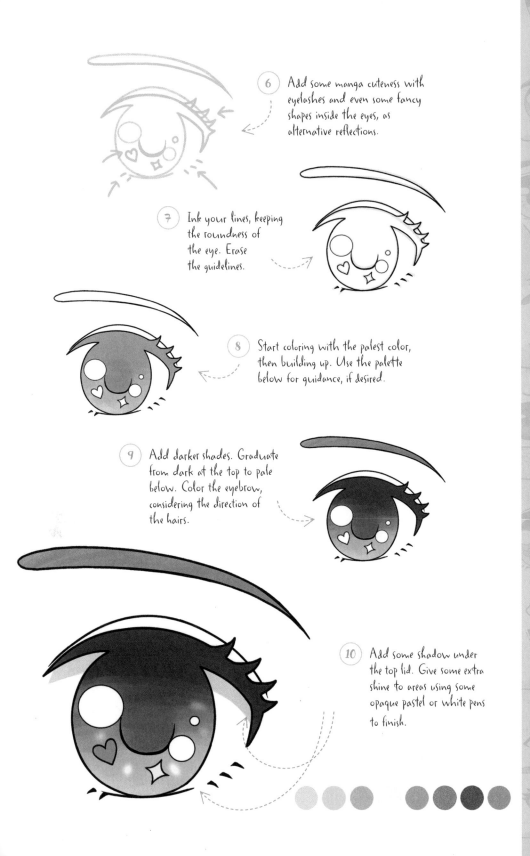

6 Add some manga cuteness with eyelashes and even some fancy shapes inside the eyes, as alternative reflections.

7 Ink your lines, keeping the roundness of the eye. Erase the guidelines.

8 Start coloring with the palest color, then building up. Use the palette below for guidance, if desired.

9 Add darker shades. Graduate from dark at the top to pale below. Color the eyebrow, considering the direction of the hairs.

10 Add some shadow under the top lid. Give some extra shine to areas using some opaque pastel or white pens to finish.

Cool Eye

Some characters suit cool over cute. Their eyes will need to be sharper in look and more angular in shape.

① For the top lid, draw a horizontal, slightly curved line, with one side higher than the other.

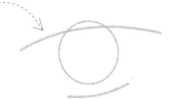

② Draw a circle that slightly overlaps the line. Leave some space underneath the circle and add a short curved line.

③ Adjust the shape of the whole eye, thickening the top lid a little. Indicate the pupil in the center, keeping it small.

④ Add a couple of highlights (see note below). Imagine where the light is coming from, then add an oval highlighted part inside the main eye circle. Add a small reflection oval, diagonally across from the first highlight.

Note:
Sometimes cool-looking eyes are cooler without highlights, which can make the eyes look too cheerful.

⑤ Draw the eyebrow, one side up and the other closer to the eye, and in a sharp, angular shape.

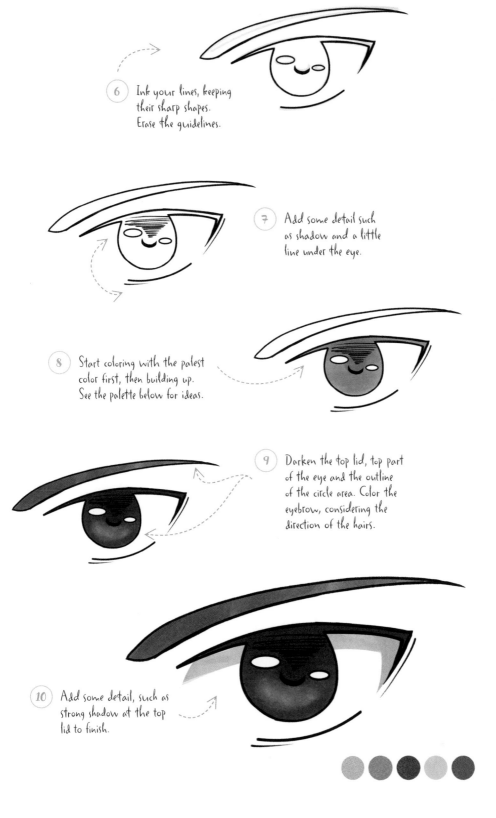

6) Ink your lines, keeping their sharp shapes. Erase the guidelines.

7) Add some detail such as shadow and a little line under the eye.

8) Start coloring with the palest color first, then building up. See the palette below for ideas.

9) Darken the top lid, top part of the eye and the outline of the circle area. Color the eyebrow, considering the direction of the hairs.

10) Add some detail, such as strong shadow at the top lid to finish.

17

Nose

Will your character have a wide, long, or small nose? It's up
to you, but decide before you draw your base shape.

1 Draw an isosceles
triangle. Its balance will
vary depending on what
kind of nose you would
like to draw.

2 Draw a slightly curved line
from the top (the ridge)
and another curved line
connecting the bottom points
(the bottom of the nose).

3 Add the details — here,
the ridge and nostrils —
but keep it simple.

4 Ink the inner guidelines,
remembering to keep it simple.
Erase the rest.

5 Color the nose as part of the face. Add a shadow
underneath and a highlight with a white opaque pen
on the tip of the nose. For a healthy-looking character,
add a touch of blush (in a darker shade) to the ridge.

Also try:

Skin tones

A

No-ridge version,
suits all nose types.

B

Ridge with a small
indication of the
wing of the nose.

C

Just an indication
of the wing of
the nose.

Nose

While it's more than just a triangle, a nose profile
works best when it's kept simple.

1. Draw a right-angled triangle.
Change the balance according
to what kind of nose you
would like to draw.

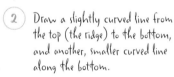

2. Draw a slightly curved line from
the top (the ridge) to the bottom,
and another, smaller curved line
along the bottom.

3. Add a line to
indicate the nostril.

4. Ink the nose, keeping it
simple. There is no need
to add too much detail.
Erase the guidelines.

5. Color the nose as part of the face (see palette below
for skin tone ideas). Add a shadow underneath and
a highlight with a white opaque pen on the tip of
the nose (optional).

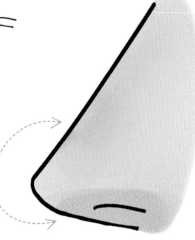

Also try:

No-nostril version — a
nose can be this simple!

Skin tones

Front
Mouth

Curvy lines, as shown in this example, will give soft, full lips, while slightly square shapes are best for more angular mouths.

1 Draw a horizontal line for the center of the lips.

2 Add a twin-peaked line on top and a curved line connecting both sides at the bottom. This is the template shape of the mouth.

3 Emphasize those significant parts of the mouth, in this case, the upper lip arch, center of the mouth, and the bottom of the lower lip, where shadow falls.

4 Ink your lines, omitting the top and bottom arches for some characters. Erase the guidelines.

5 Color the mouth to suit the face of your character. Darken the upper lip slightly. Add some highlights with a white opaque pen if your character would use makeup.

Blush and lip tones

Profile
Mouth

Turn the triangle base shape on its side for your
character's mouth from a side view.

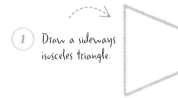

1. Draw a sideways isosceles triangle.

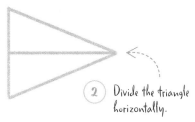

2. Divide the triangle horizontally.

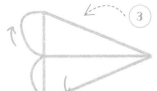

3. Add curved lines as indicated by the arrows.

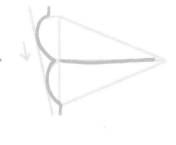

4. Adjust the balance to suit the desired mouth shape. Use a line as the arrow shows to strike a good balance.

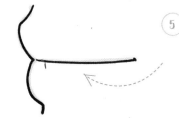

5. Ink your lines, using curvy lines as here for soft lips or squared-off shapes for a more angular mouth. Erase the guidelines.

Blush and lip tones

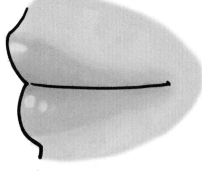

6. Color the mouth to suit the face of your character. Darken the upper lip slightly. Add some highlights with a white opaque pen if your character would use makeup.

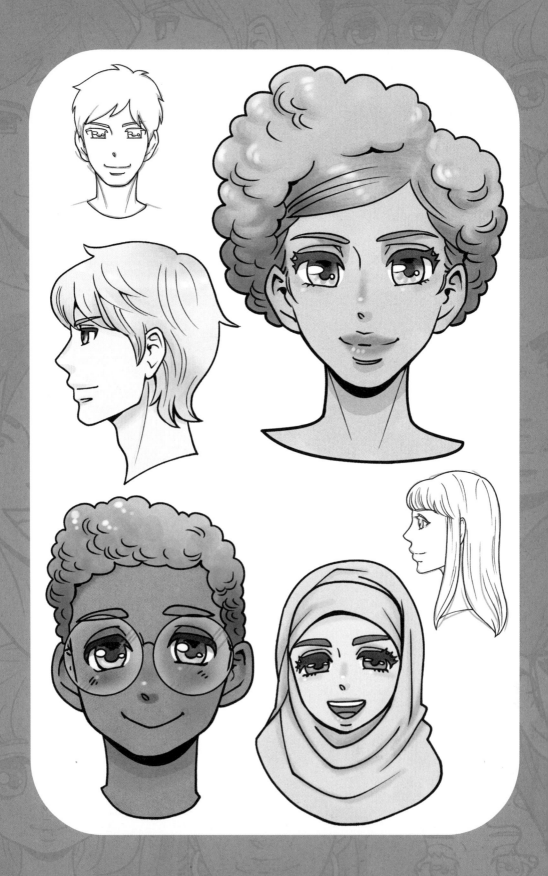

Manga Faces

Front
Female Face

A useful rule here is to remember that the longer your vertical line,
the longer your character's face will be.

1 Draw a circle and divide it into quarters.

2 Extend the center vertical line to an appropriate length for the bottom of the chin. Connect the tip of the extended line to both ends of the horizontal line with curved lines.

3 Mark the positions of the eyes, nose, and mouth. Add the ears and width of the neck, which are related to the position of the eyes.

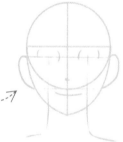

4 Plan the hairstyle. Consider the type of hairstyle the character might have, where the hair is parted and how much volume the hair might have.

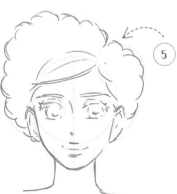

5 Add more detail. Adjust the positions and shapes of each facial feature, taking into account the overall balance. For curly hair, as here, use wavy lines.

⑥ Ink your lines. Define the face line first, and use it as a frame of reference for the balance of the facial features. Erase the guidelines.

⑦ Add some depth by thickening some lines where shadows fall, such as under the chin and hair.

⑧ Decide on the color scheme (see palette below) and start with the palest color first.

⑨ Add more depth on shadowy areas, considering where the light is coming from. Check the balance and contrast of the darkest and lightest areas. Deepen the complexion on some areas, such as the nose bridge, cheeks, under the eyes, and so on.

⑩ Add highlights with a white or pastel opaque pen or ink.

Note:
Consider where the light is coming from when adding highlights to eyes, hair, and other features.

Front
Male Face

In general, use sharper lines and
squared-off shapes for definition.

(1) Draw a circle and
divide it into quarters.

(2) Extend the center vertical line to
an appropriate length — the longer
the line, the longer the face.
Then connect the tip of the
extended line to both ends of the
horizontal line with curved lines.

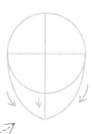

(3) Mark out the eyes, nose, and
mouth. Add the ears and neck
in relation to the position of
the eyes.

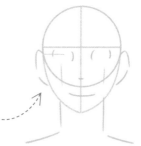

(4) Plan the hairstyle. Consider the parting
and volume of the hair. Also, adjust the
face, neck, and shoulder lines.

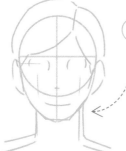

(5) Add more detail. Adjust the
position and shape of the facial
features, taking the overall
balance into account. Make the
eyes slightly square.

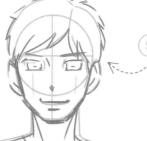

26

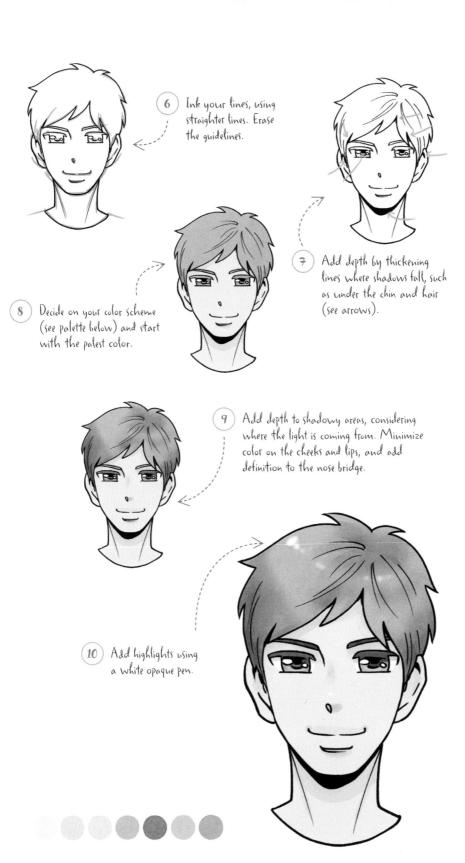

6 Ink your lines, using straighter lines. Erase the guidelines.

7 Add depth by thickening lines where shadows fall, such as under the chin and hair (see arrows).

8 Decide on your color scheme (see palette below) and start with the palest color.

9 Add depth to shadowy areas, considering where the light is coming from. Minimize color on the cheeks and lips, and add definition to the nose bridge.

10 Add highlights using a white opaque pen.

27

Profile
Female Face

By slowly adding layers of detail, you can create depth and character for the face.

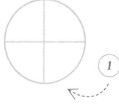

1. Draw a circle and divide it into quarters.

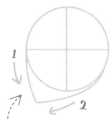

2. Extend a lower quarter to an appropriate length with a curved line, and add another curved line on the other side to form a rough jawline.

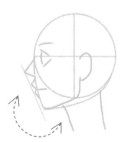

3. Add the facial features in the appropriate positions and define the jawline.

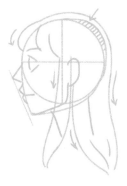

4. Add two slightly slanting lines for the neck. Then add a little dimension to the top of the head, followed by lines to outline the hair shape.

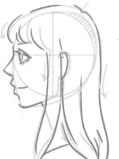

5. Emphasize the main external outlines, thinking of the flow of the hair.

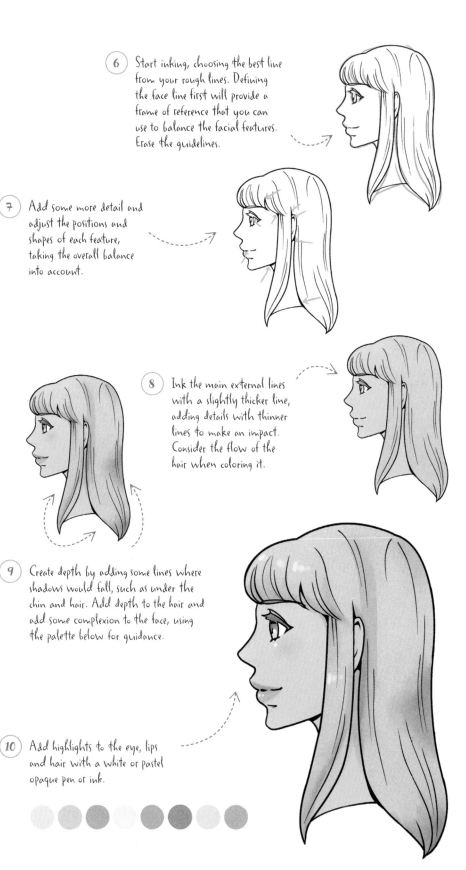

6 Start inking, choosing the best line from your rough lines. Defining the face line first will provide a frame of reference that you can use to balance the facial features. Erase the guidelines.

7 Add some more detail and adjust the positions and shapes of each feature, taking the overall balance into account.

8 Ink the main external lines with a slightly thicker line, adding details with thinner lines to make an impact. Consider the flow of the hair when coloring it.

9 Create depth by adding some lines where shadows would fall, such as under the chin and hair. Add depth to the hair and add some complexion to the face, using the palette below for guidance.

10 Add highlights to the eye, lips and hair with a white or pastel opaque pen or ink.

Male Face

Tone it down by keeping the complexion on male faces to a minimum.

(1) Draw a circle and divide it into quarters.

(2) Extend a lower quarter to an appropriate length with a curved line, and add another curved line on the other side to form a rough jawline.

(3) Add the nose and ear, and define the jawline. Add two slightly slanted lines for the neck, making the neck slightly wider. Add the other facial features.

30

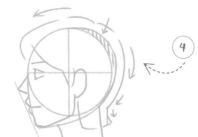

(4) Add a little volume to the back of the head. Give a shape to the hairstyle, considering the flow of hair.

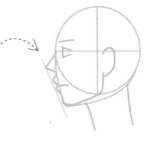

(5) Add more detail, adjusting the position and shape of each part. Square off the chin and jawline.

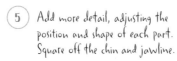
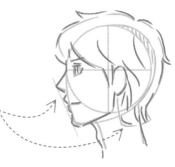

6 Ink your lines, starting by thickening the main external lines, then adding detail with slightly thinner lines to make an impact. Erase the guidelines.

7 Add depth by thickening lines where shadows fall, such as under the chin and hair (see arrows).

8 Decide on your color scheme (see palette below) and start with the palest color.

9 Add shadows, considering where the light is coming from. Check the balance and contrast of the darkest and lightest areas.

10 Add highlights with a white opaque pen.

Young Female Face

In this case, shorter is better for the vertical extension line, to create a round face shape that looks young and cute.

1 Draw a circle and divide it into quarters.

2 Extend the center vertical line to the appropriate length. Then connect the tip of the extended line to both ends of the horizontal line with curved lines.

3 Mark out the eyes, nose, and mouth. Set the position of the eyes a little lower than usual. Then add the ears and neck in relation to the position of the eyes.

4 Plan the hairstyle. Consider the bangs, parting, and volume of the hair. A round shape with a fluffy silhouette works well for a young character.

5 Add detail, adjusting the position and shape of each feature, taking the overall balance into account. An exaggerated slant around the eyes with less white showing tends to look cute. Keep the nose simple.

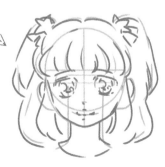

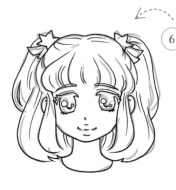

6 Ink your guidelines using rounded, soft lines. Erase the guidelines.

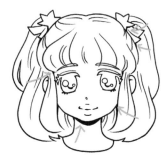

7 Add depth by thickening lines where shadows are cast, such as under the chin and hair (see arrows). For a youthful face, keep the strong shadows to a minimum.

8 Decide on your color scheme and start with the palest color first. Pastel shades work well here (see palette below).

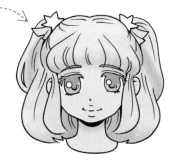

9 Add depth to shadowy areas, but again, do not overdo it. Add some complexion to areas such as the nose bridge, cheeks, and lips.

10 Add highlights using some pastel colors.

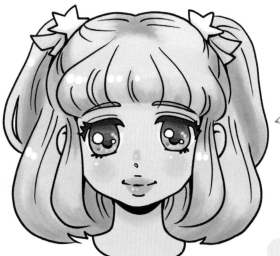

Note:
Keep the shape of the highlight round to enhance the cuteness.

Young Male Face

Make your character exude an adorable shyness
by adding a rosy complexion.

① Draw a circle and divide it into quarters.

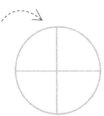

② Extend the center vertical line to an appropriate length — short works best for a round, young look.
Then connect the tip of the extended line to both ends of the horizontal line with curved lines.

③ Add the eyes, nose, and mouth. Setting the position of the eyes a little lower than usual will give your character a young or baby face. Add the ears and neck in relation to the position of the eyes.

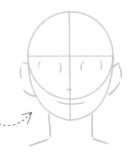

④ Plan the hairstyle. For a style like this one, decide on the shape of the forehead first, and then sketch the silhouette of the hairstyle. Add the rough sketch for glasses at this stage, if desired.

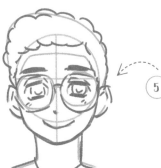

⑤ Adjust the position and shape of each feature, taking the overall balance into account. Slanted eyes with large irises tend to look cute, and leaving some distance between the eyes and eyebrows will give a relaxed look. Keep the nose simple.

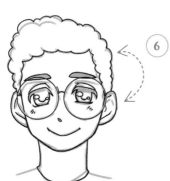

6) Ink your lines. Use fluffy lines for curly hair. Lines on cheeks can indicate rosiness and enhance the character's shyness. Erase the guidelines.

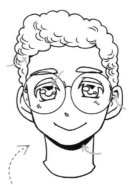

7) Thicken some areas of the lines where shadows fall, such as under the chin and hair (see arrows). Minimize strong shadows.

8) Decide on your color scheme and start with the palest color.

9) Add depth to shadowy areas, but again, do not overdo it. Add complexion to some areas, such as the nose bridge and cheeks.

10) Add highlights and reflections on the glasses using white or pastel opaque pen or ink.

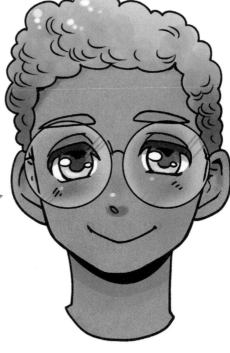

Cool Female Face

Here, your vertical extension line can be a little longer,
as a longer face creates a cool impression.

1 Draw a circle and
 divide it into quarters.

2 Extend the center vertical line to an
 appropriate length. Then connect the tip
 of the extended line to both ends of
 the horizontal line with curved lines.

3 Mark out the eyes, nose, and
 mouth. Then add the ears and
 neck in relation to the position
 of the eyes.

4 Plan the hairstyle. Here is
 a cool, asymmetrical style
 with straight hair. Consider
 the parting and the volume
 of the hair. If your
 character is going to
 wear glasses, roughly add
 them in.

5 Add detail. Adjust the position
 and shape of each feature,
 taking into account the overall
 balance. To enhance coolness,
 use sharp lines and make the
 eyes slightly wider than usual.

6 Ink your lines, starting with the most important areas, such as the face and hair outlines, then add detail. Erase the guidelines.

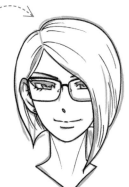

7 Add depth by thickening lines where shadows fall, such as under the chin and hair (see arrows).

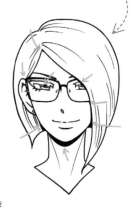

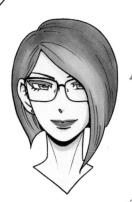

8 Decide on your color scheme and start with the palest color. Cold colors are a good choice here (see palette below).

9 Add depth to shadowy areas, considering where the light source is coming from. Exaggerating the contrast will add drama.

10 Add highlights with a white opaque pen. Keep the shape of the highlights sharp and slick.

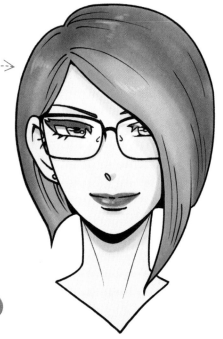

Cool Male Face

Using sharp, definite lines will enhance the coolness of features, such as floppy bangs, almond-shaped eyes, and lop-sided smiles.

1 Draw a circle and divide it into quarters.

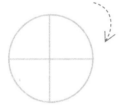

2 Extend the center vertical line to an appropriate length — long works best for a cool look. Then connect the tip of the extended line to both ends of the horizontal line with curved lines.

3 Mark out the eyes, nose, and mouth. Then add the ears and neck in relation to the position of the eyes.

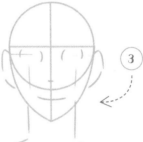

4 Plan the hairstyle. Here, the style hides one eye. Consider the parting and volume of the hair.

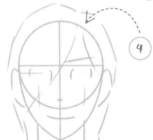

5 Add detail, adjusting the position and shape of each feature, taking the overall balance into account. The sharp half-closed eye and casual lop-sided smile enhance the coolness. Square off the chin.

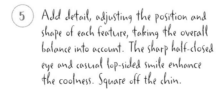

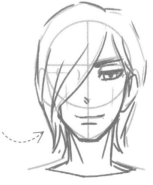

6　Ink your lines, starting with important areas, such as the face and hair outlines, and then add the details. Erase the guidelines.

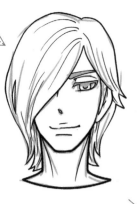

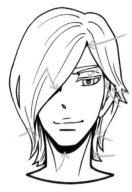

7　Add depth by thickening lines where shadows fall, such as under the chin and hair (see arrows). Add more shadow to a cool character than you would to a cute one.

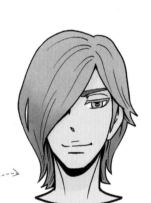

8　Decide on your color scheme and start with the palest color. Cold colors are a good choice here (see palette below).

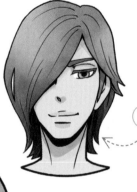

9　Add depth to shadowy areas, considering where the light is coming from. The bigger the contrast, the more dramatic the image.

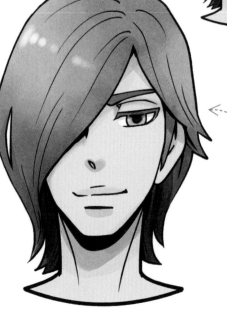

10　Add highlights with a white opaque pen. For particularly cynical or dull characters, omit the highlights from the eyes.

More Female Faces

Now that you know how to draw a female face, try these variations!

For a round, chubby face, make the chin less sharp and widen the jawline slightly. Add a pink tone to the wider area of the cheeks to enhance the character's roundness and healthy cuteness.

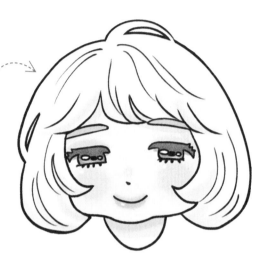

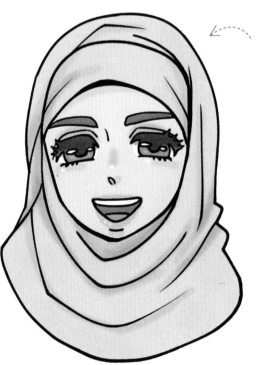

For a hijab, draw a rough head first, then add a planning sketch of the hijab. Use slightly thicker lines for the most distinctive folds, such as the ones that cover the forehead, go around the face, and under the chin. Then add the small creases.

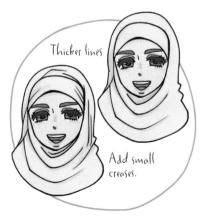

Thicker lines

Add small creases.

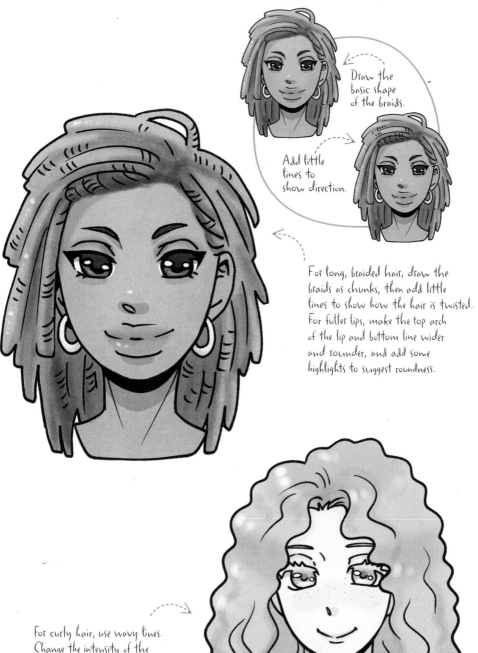

Draw the basic shape of the braids.

Add little lines to show direction.

For long, braided hair, draw the braids as chunks, then add little lines to show how the hair is twisted. For fuller lips, make the top arch of the lip and bottom line wider and rounder, and add some highlights to suggest roundness.

For curly hair, use wavy lines. Change the intensity of the wave according to how curly it is. For thin lips, you only need to draw one line for the mouth, and then color thinly around it. For average-thickness lips, add the line for the bottom lip. For natural-looking lips, make the outlines of the color less defined.

More Male Faces

Now that you know how to draw a male face, try these variations!

For a round, chubby face, make the chin less defined, and make the whole shape round and wide. Add a slight blush tone under the eyes to show high, round cheeks.

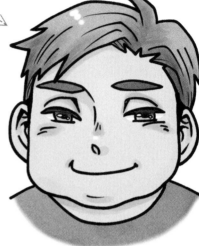

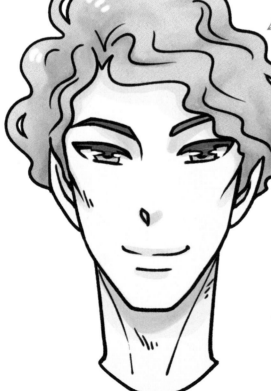

For a long, bony face, add a slanted line on the side of the cheeks for defined, high cheekbones. Add slanted lines to define the neckline, and some short lines on the side of the neck to enhance boniness. Add some short lines to show the Adam's apple.

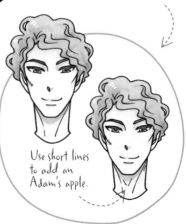

Use short lines to add an Adam's apple.

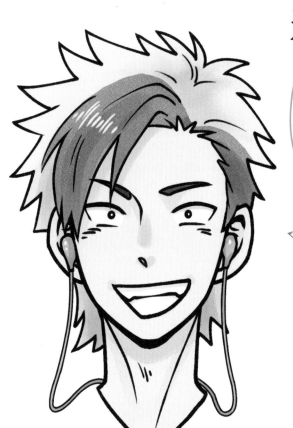

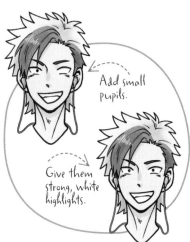

Add small pupils.

Give them strong, white highlights.

For a mischievous face, use small pupils in the eyes. The position of the pupils is important in this type of face. For the earphones, make sure that both are the same shape, and add strong, white highlights to enhance their solidness.

For a square face, widen the chin and use straight lines to make the jawline square. A wider neck indicates a well-built person. For a fuller lip, add the upper lip line but do not define the arch too much. Add highlights to the nose to show height and width.

Manga Expressions

Laughing, surprised, angry, or sad—now that you've mastered
the manga-style face, try these different expressions!

For a sad face, many facial features
turn downward. The eyebrows are
slanted down, with some vertical
lines in the middle of the brows.
The sides of the mouth go down,
and the eyes look down.

44

For a laughing face, apart from the
mouth shape, it's important that the
cheeks are raised and the eyes are
closed or half-closed. If you use
normal eyes it looks like a fake
laugh. The closed eyes for a laughing
face are different from the closed
eyes for a sleeping or sad face
(see page 58). The eyebrows are
raised but relaxed, and the cheeks
might be rosy from excitement.

For a surprised face, just open the eyes and mouth. Even if the mouth is closed, with fully open eyes like these your character will look stunned. For eyebrows, this shape is for general surprise. If you use angry-style eyebrows (see below) for this face, he would look shocked or disgusted. If you keep the eyebrows and eyes, but change the mouth to a laughing shape, the character will look pleasantly surprised.

An angry face is a tense face. The eyebrows are angled, with additional deep lines caused by tension. For an angry mouth, you can use this kind of teeth-grinding shape.

Either open up the character's eyes or narrow them, as in this example. Draw the eyes sharper, with the outside edges going up at an angle to enhance the tension.

The mark on the forehead is one of the classic symbols used for manga expression. This one is for anger, and shows raised veins. If you put this mark on the forehead of a smiling person, it looks like the person is trying to smile to hide their anger. But using this symbol makes images slightly comical, so think carefully when you use them.

Chibi Style

Front
Chibi Eye

A combination of simple shapes, magical colors, highlights,
and detail give this eye its cute look.

1. Draw a horizontal curved line, and then draw a circle underneath. Add a short curved line below.

2. Adjust the shape of the whole eye, thickening the top lid a little. Add an outline of the large pupil in the center and a line across the middle of the eye, dividing the pupil. Add a parallel line above the eye, for an eyebrow.

3. Shape the eyebrow. Consider where the light source is coming from, and then add an off-round big highlight inside the main circle. Add a smaller reflection diagonally across from the first highlight. Play around by adding cute stars or heart-shaped sparkles too.

Note:
Although the right and left eye are usually mirror images, the positions of the highlights are not.

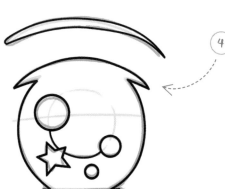

4. Ink your guidelines. Keep it simple, and try to draw all the lines evenly and smoothly. Erase the guidelines.

5. Pick the color of the eye and start coloring, with the palest shade first.

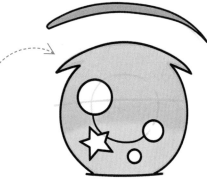

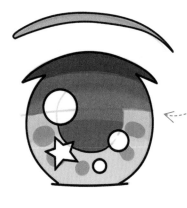

6. Add a darker shade, graduating from dark at the top to paler at the bottom.

7. Add final detail, such as shadow below the eyelid and extra sparkles, using some opaque pastel or white pens.

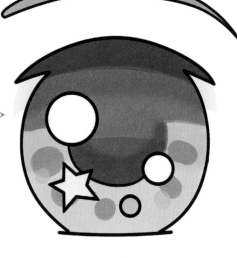

Profile
Chibi Eye

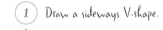

This side view of a chibi eye can be achieved with a simple triangle to help you position the circle of the eye.

(1) Draw a sideways V-shape.

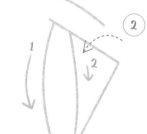

(2) Add a curved line to close the V-shape (see arrow 1). Then add a mirrored line (see arrow 2) to compose the iris. Draw a short line parallel to the eye, for the eyebrow.

(3) Using your guidelines, draw a shape as shown here. Eyes for chibi characters are simpler (but cuter!) than ordinary manga eyes.

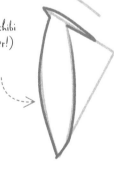

(4) Add some details, such as an indication of the bottom half of the pupil, highlights, and sparkles. Define the eyebrow shape.

5 Ink your lines, using even, smooth strokes. Erase the guidelines.

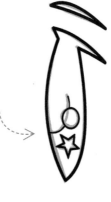

6 Start coloring, building from the palest color.

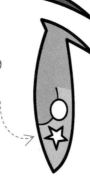

7 Shade your drawing, graduating from dark at the top to light at the bottom.

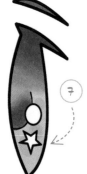

8 Add final detail, such as the shadow below the eyelid, and some extra sparkles using opaque pastel or white pens.

Front
Chibi Face

Use the steps you've just learned to add wide eyes to this circular face.

1. Draw a circle.

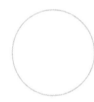

2. Divide the circle into quarters, and then divide the lower half horizontally into two.

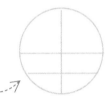

3. Add a squashed oval shape that is slightly wider than the circle at the bottom.

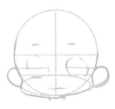

4. Define the face shape. Add the positions of the eyes, eyebrows, ears, and mouth.

5. Plan the hairstyle and build it up section by section — consider the shape of the bangs, the parting, and the shape and length of any bunches or pigtails.

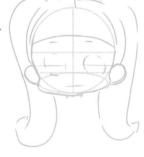

6 Draw a more detailed rough, adding details such as the inside of the eyes and any hair accessories (here, ribbons).

7 Ink your lines, keeping the shapes simple and the lines even and smooth. Erase the guidelines.

8 Plan the color scheme and block-color the face (see palette below), as shown.

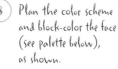

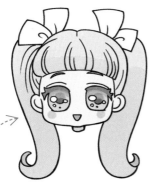

9 Add shading and details, such as rosy cheeks and inside the eyes. Chibis can be more stylized than ordinary manga style, but still don't overdo your shading.

10 Add final detail, such as shadow under the eyelid. Add some extra sparkles to the eyes and hair by using opaque pastel or white pens.

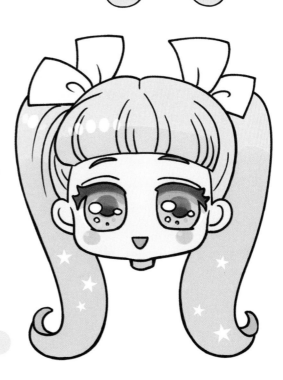

Profile
Chibi Face

The key difference in chibi-style profiles is the lack of a distinctive nose.

① Draw a circle. ② Divide the circle into quarters, and then divide the lower half horizontally into two.

③ Add a squashed oval shape that is slightly wider than the circle at the bottom, with its center slightly to the left (see arrow).

④ Define the face shape. Mark the positions of the eyes, eyebrows, ears, and neck.

⑤ Plan the hairstyle and build it up section by section, considering the shape of the bangs and any spiky areas.

Note:
Even if you are drawing an exaggerated manga hairstyle, think about the direction and flow of each section of hair. This process will make your drawings more believable.

54

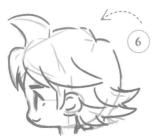

6 Draw a more detailed rough. You do not need to add a nose to chibi-style characters.

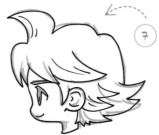

7 Ink your lines, keep the shapes simple, and the lines even and smooth. Erase the guidelines.

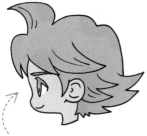

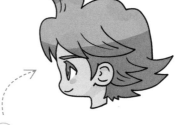

8 Plan your color scheme (see palette below) and block-color your drawing, as shown.

9 Add shading and detail, such as the cheeks and inside the eyes. Do not overdo the shading, but going bold on the hair will give your character some chibi style.

10 Add final detail, such as shadow under the eyelid. Add extra highlights using opaque white pen, keeping the shapes stylized.

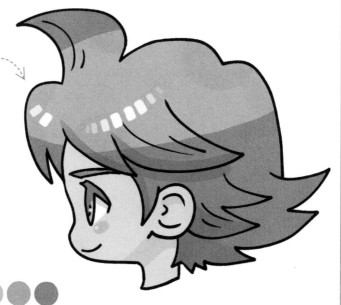

Chibi Face

Now that you've learned how to draw a chibi face, try these variations!

Even villainous characters can be drawn in chibi style. Try to simplify sharp eyes into semicircle shapes, and draw them larger than usual, but keep the pupil small to avoid making the character look too cute.

Use fluorescent opaque pen to draw sharp, wicked highlights.

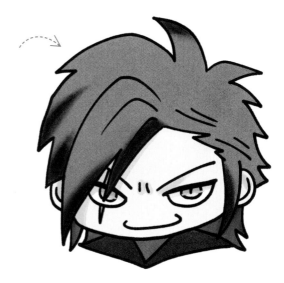

Try to stylize the look of accessories, in this case, a flower crown. You do not need to add too much detail, but emphasising significant shapes is key.

A few slim, oval dots for the lower lashes work well.

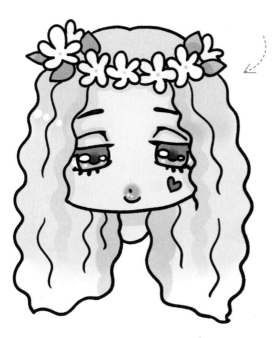

Use stylized shapes for highlights. Circles and rounded-off squares work well.

For this character, the square face structure is rounded off in the corners to keep it in a chibi style. Facial hair such as sideburns and beards can be realized simply by using diagonal lines.

For this hairstyle, focus on the shape and simplify it. Then add the details, but do not overdo it.

Draw the face first, before adding any eyewear, such as glasses.

Draw chibi characters with even, crisp lines, and pay extra attention to accessories.

Facial Expressions
Chibi

The basic rules for drawing facial expressions are the same for chibi style as they are for ordinary manga style. However, for chibi style, the lines and shapes are simplified and exaggerated a little.

For a laughing face, draw a mouth in the shape shown here, keeping the inside simple. To draw a genuine laugh or smile, the eyes should be closed, or at least half-closed, because of the raised cheeks.

Adding blushes on the cheeks makes a character look excited and happy.

Both laughing and sad eyes are closed, but the shapes are different. Sad closed eyes are not forced closed by the cheeks, so the curve is downward. These eyes can also be used for drawing a sleeping character.

Another distinctive sad feature is the eyebrows. They slant up toward each other, with lines in between them.

This example shows the mouth in a sighing pout. You could also use the turned-down mouth of an angry character.

Sharp, narrowed eyes and tensed eyebrows like this will convey anger. Note the symbol of anger on the forehead, which works well with chibi style.

Add some lines and rosy color to the cheeks. They help to make the character look cute but angry!

For a surprised face, make the eyes and mouth wide-open.

Some sparkles emphasize surprise and amazement. Omitting the sparkles and rosy cheeks, and replacing the round eyebrows with angry-shaped eyebrows, will create a shocked or disgusted face.

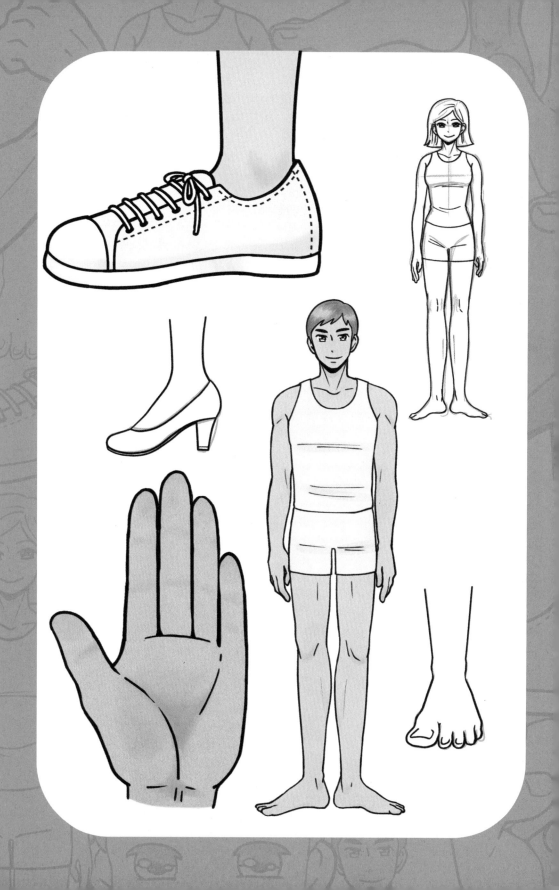

Manga Body

Female
Body

Use the techniques below to help you build the outline
of the body before adding detail. Keep the lines smooth.

1 The normal manga human
figure is seven to eight heads
tall, so draw the required
number of circles in a line.
Add a vertical line through
the middle of the circles.

1
2
3
4
5
6
7
8

Note:
You can find out how
to draw each limb later
in this book
(see pages 72–79).

2 Add horizontal lines
as suggested here to
indicate the position
of each body section.

1
2

3 Using the top sphere as the head,
add the neck. Add narrow shoulders
just below the top horizontal line.
The second horizontal line is the waistline.
Between those two lines, draw two
rectangular chunks for the chest and
midriff. Then add a rounder chunk as
the hip area underneath. See the picture
for the recommended balance.

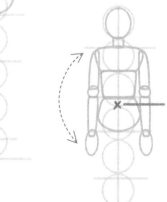

4 'X' marks the position of the belly button.
As the dark-blue line shows, the elbow is
slightly higher than the belly button. Now
add in rough shapes for the upper arms,
elbows, lower arms, wrists, and hands.

5 The third horizontal line from the bottom shows the knee level. The second line from the bottom is the ankle level. When standing straight, the hands reach the middle of the thighs (see the dark-blue line). With these levels in mind, add the thighs, knees, lower legs, ankles, and feet.

6 Now draw a rough sketch with more natural lines. For the average figure, use soft, curvy lines, especially around the shoulders, hips, and waist.

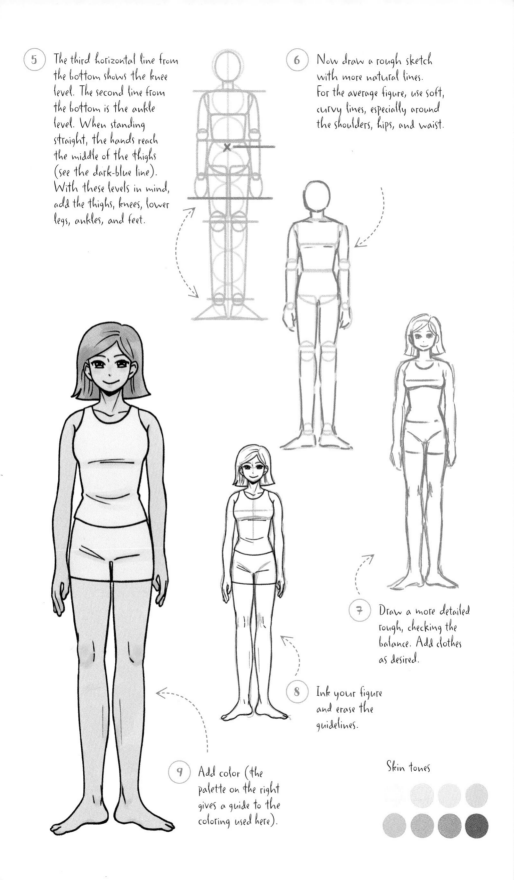

7 Draw a more detailed rough, checking the balance. Add clothes as desired.

8 Ink your figure and erase the guidelines.

9 Add color (the palette on the right gives a guide to the coloring used here).

Skin tones

Male
Body

Use the techniques below to help you build the outline
of the body before adding detail. Remember to give this
character wider, more muscular shoulders.

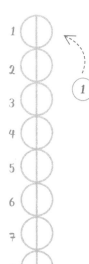

(1) The normal manga
human figure is seven to
eight heads tall, so draw
the required number of
circles in a line. Add a
vertical line through the
middle of the circles.

(2) Add horizontal lines
as suggested here, to
indicate the position
of each body section.

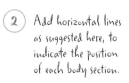

(3) Using the top sphere as the head,
add the neck. Add wide shoulders
just below the top horizontal line.
The second horizontal line is the
waistline. Between those two lines,
draw two rectangular chunks for
the chest and midriff.

Then add another square chunk
as a hip area underneath. See the
picture for the balance.

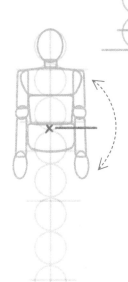

(4) 'X' marks the position of the belly button.
As the dark-blue line shows, the elbow is
slightly higher than the belly button. Now
add in rough shapes for the upper arms,
elbows, lower arms, wrists, and hands.

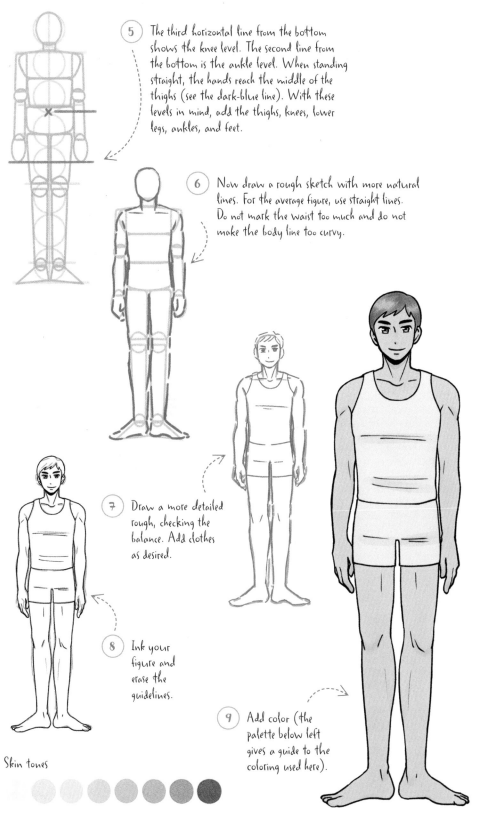

5 The third horizontal line from the bottom shows the knee level. The second line from the bottom is the ankle level. When standing straight, the hands reach the middle of the thighs (see the dark-blue line). With these levels in mind, add the thighs, knees, lower legs, ankles, and feet.

6 Now draw a rough sketch with more natural lines. For the average figure, use straight lines. Do not mark the waist too much and do not make the body line too curvy.

7 Draw a more detailed rough, checking the balance. Add clothes as desired.

8 Ink your figure and erase the guidelines.

9 Add color (the palette below left gives a guide to the coloring used here).

Skin tones

Chibi
Body

Chibi proportions are based around two circles. The face should take up all of one circle and the entire body should fit into the second circle.

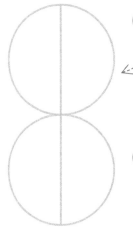

1 The chibi body and head are usually two heads tall. Draw two circles and a vertical line down the center.

2 Divide both circles into two horizontally. Divide the bottom half of the top circle into two horizontally (1) and add a squashed oval shape (2).

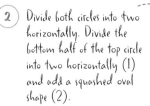

Note:
For the face detail, refer to the chibi face section (see pages 48–59).

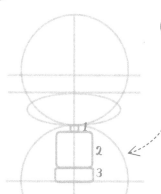

3 Draw three rectangles within the upper half of the lower circle: a small, narrow rectangle for the neck (1), a large one for the torso (2) and a medium-sized one for the hips (3).

Note:
For a more feminine chibi figure, narrow the shoulders and emphasize the waist with curvier lines.

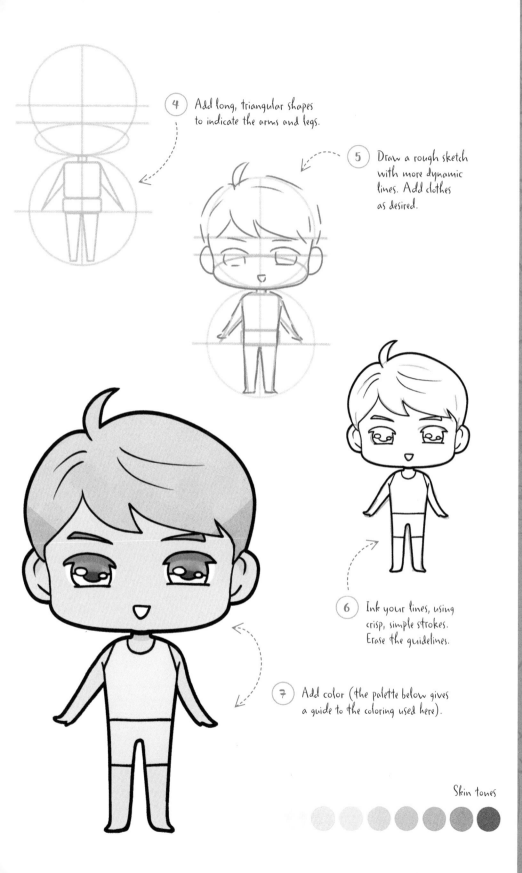

4 Add long, triangular shapes to indicate the arms and legs.

5 Draw a rough sketch with more dynamic lines. Add clothes as desired.

6 Ink your lines, using crisp, simple strokes. Erase the guidelines.

7 Add color (the palette below gives a guide to the coloring used here).

Skin tones

Open
Hand

These simple steps will help you to break down the hand into easy-to-draw sections.

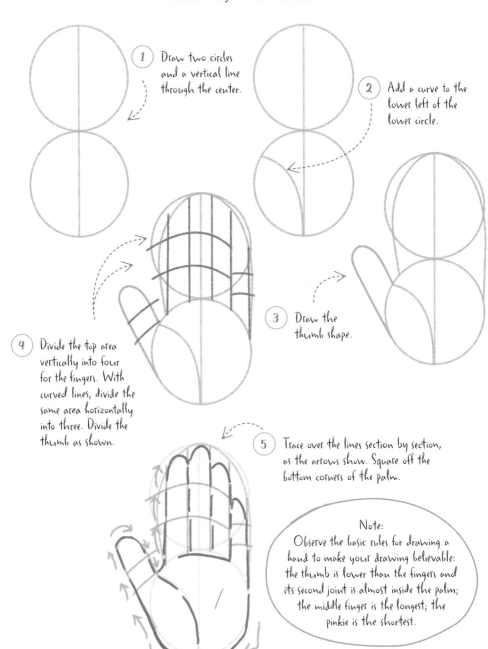

1. Draw two circles and a vertical line through the center.

2. Add a curve to the lower left of the lower circle.

3. Draw the thumb shape.

4. Divide the top area vertically into four for the fingers. With curved lines, divide the same area horizontally into three. Divide the thumb as shown.

5. Trace over the lines section by section, as the arrows show. Square off the bottom corners of the palm.

Note:
Observe the basic rules for drawing a hand to make your drawing believable: the thumb is lower than the fingers and its second joint is almost inside the palm; the middle finger is the longest; the pinkie is the shortest.

68

6) Ink your lines, section by section rather than in one go. Be conscious of the joins and slight gaps between fingers (see arrows). Erase the guidelines.

7) Add a couple of prominent lines.

8) Color the hand (see palette below for the colors used here).

9) Add some shading to the middle of the palm and to the joints. Also, add a ruddy complexion to the fingertips and thenar (ball of thumb) if you are drawing a healthy-looking or outdoor character.

Skin tones

Hand

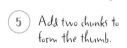

Now that you've mastered the basic outline of a hand,
try drawing this closed-fist variation.

(1) Draw a circle and
divide it vertically.

(2) Add a curve in
the lower left
section.

(3) Draw a skewed rectangle
covering about
two-thirds of the circle,
as shown.

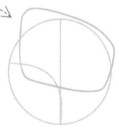

(4) Divide the rectangular shape vertically
into four for the fingers. Then draw
a line across, as shown, for where the
fingers bend.

(5) Add two chunks to
form the thumb.

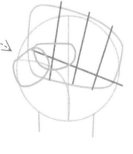

6 Trace over the lines section by section, as shown by the arrows. Square off the lower corners of the palm.

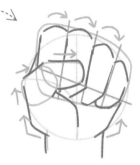

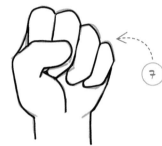

7 Ink your lines, being conscious of the joints and each section, rather than inking the whole outline in one go. Erase the guidelines.

8 Add a couple of prominent lines, including an L-shaped line to the tip of the thumb, for the nail.

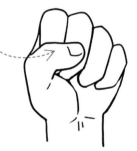

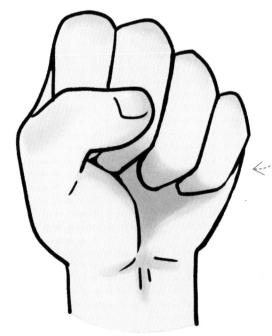

9 Color the hand. Add shading to the middle of the palm and to the top of the fingers, where they bend into the palm.

Also, add a ruddy complexion to the fingertips and thenar (ball of thumb) if you are drawing a healthy-looking or outdoor character.

Skin tones

Arm

People come in many shapes and sizes, but a typical
arm is smooth and softly curving.

(1) Plan the bone structure. Start by drawing a
circle for the shoulder, which represents the
deltoid muscle. Then draw the upper arm bone,
elbow circle, lower arm bone, wrist, and hand.
Keep the lower arm slightly longer than the
upper arm for a good balance.

(2) Shape the upper arm,
referring to the arrows.

(3) Continue to the lower arm,
again referring to the arrows.

4 Finish the rough by adding the hand and detailing the fingers and thumb.

5 Ink your guidelines, keeping it simple and the shape fairly slender. Erase the guidelines.

6 Color the arm (see the palette below for a guide to the colors used here).

7 Add some minimal shading as shown.

Skin tones

Muscular
Arm

This arm is more muscular and defined in shape than a typical arm. Remember to accentuate the tendons.

(1) Plan the bone structure. Start by drawing a larger oval for the shoulder, which represents the deltoid muscle. Then draw the upper arm bone, elbow circle, lower arm bone, wrist, and hand.

(2) Shape the shoulder and upper arm, referring to the arrows. Emphasize the deltoid and bicep muscles by using curved lines.

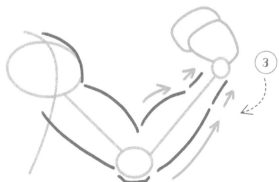

(3) Continue to the lower arm, remembering to slim down around the wrist (see arrows). Use outwardly and inwardly curved lines accordingly.

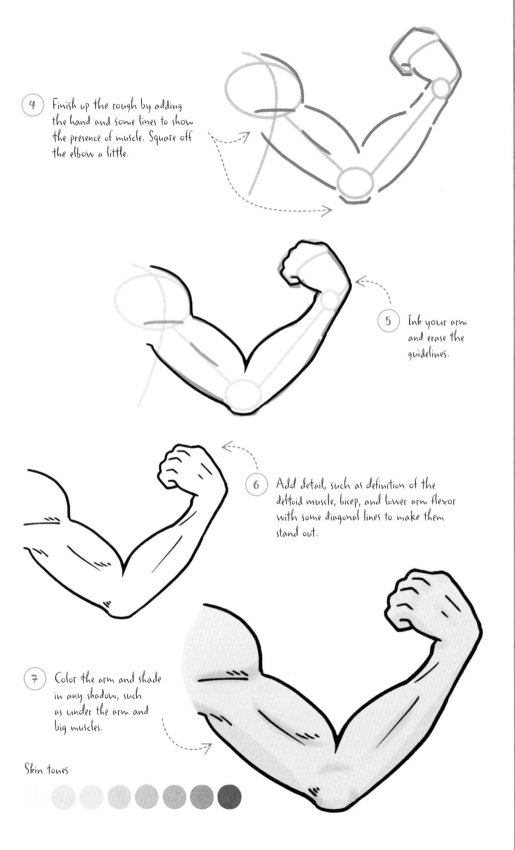

4. Finish up the rough by adding the hand and some lines to show the presence of muscle. Square off the elbow a little.

5. Ink your arm and erase the guidelines.

6. Add detail, such as definition of the deltoid muscle, bicep, and lower arm flexor with some diagonal lines to make them stand out.

7. Color the arm and shade in any shadow, such as under the arm and big muscles.

Skin tones

Leg

With these simple steps you can avoid drawing stick legs.

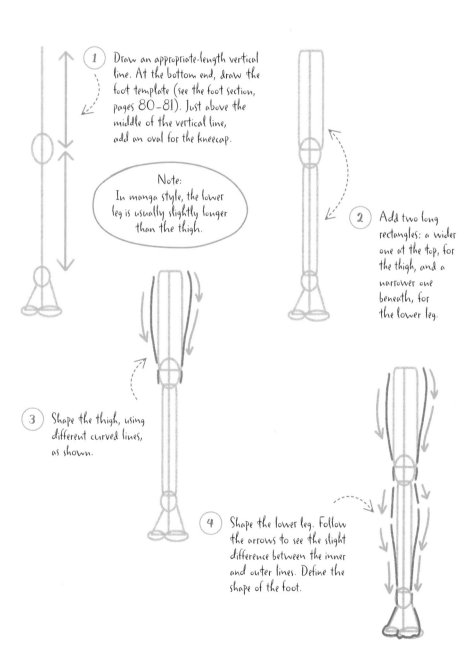

1. Draw an appropriate-length vertical line. At the bottom end, draw the foot template (see the foot section, pages 80–81). Just above the middle of the vertical line, add an oval for the kneecap.

Note:
In manga style, the lower leg is usually slightly longer than the thigh.

2. Add two long rectangles: a wider one at the top, for the thigh, and a narrower one beneath, for the lower leg.

3. Shape the thigh, using different curved lines, as shown.

4. Shape the lower leg. Follow the arrows to see the slight difference between the inner and outer lines. Define the shape of the foot.

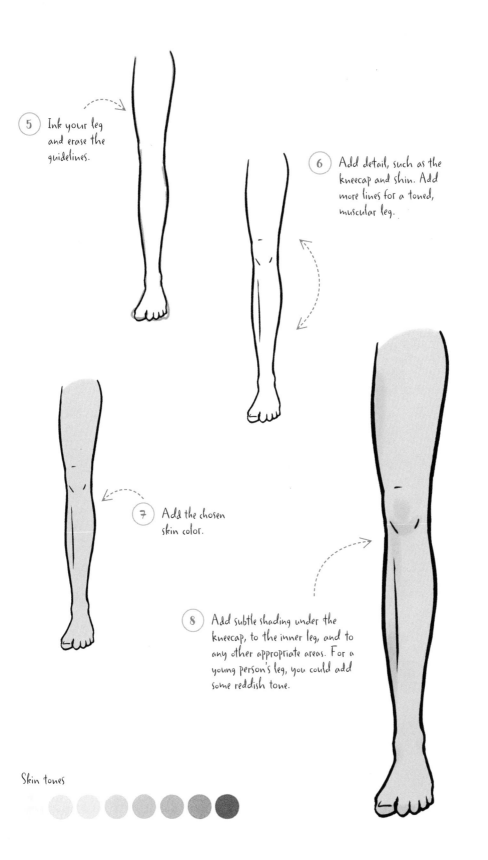

5 Ink your leg and erase the guidelines.

6 Add detail, such as the kneecap and shin. Add more lines for a toned, muscular leg.

7 Add the chosen skin color.

8 Add subtle shading under the kneecap, to the inner leg, and to any other appropriate areas. For a young person's leg, you could add some reddish tone.

Skin tones

Muscular
Leg

Depending on your character, you may want to give the legs shape and definition using these steps.

1. Draw an appropriate-length vertical line. At the bottom end, draw the foot template (see the foot section, pages 80–81). Just above the middle of the vertical line, add an oval, for the kneecap.

2. Add two long rectangles: a wider one at the top, for the thigh, and a narrower one beneath, for the lower leg.

3. Shape the thigh, using different curved lines, as shown. Make it wider than usual for a muscular leg.

4. Shape the lower leg, again making it wider than usual. Follow the arrows to see the slight difference between the inner and outer lines. Define the shape of the foot.

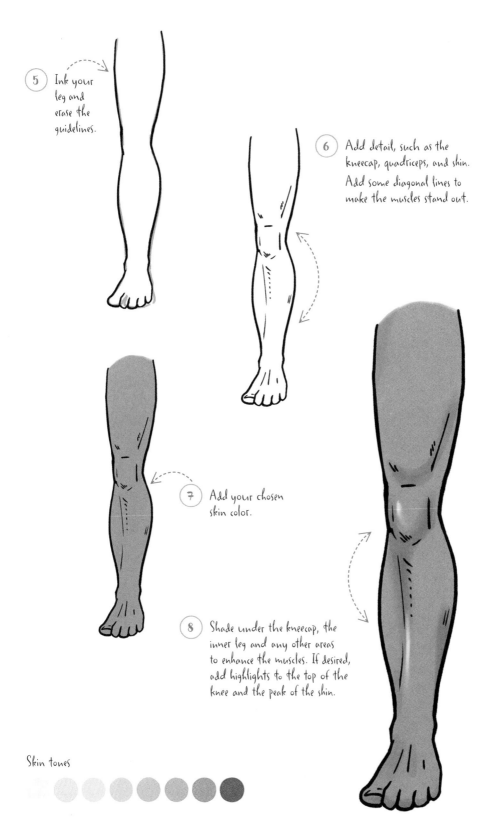

5 Ink your leg and erase the guidelines.

6 Add detail, such as the kneecap, quadriceps, and shin. Add some diagonal lines to make the muscles stand out.

7 Add your chosen skin color.

8 Shade under the kneecap, the inner leg and any other areas to enhance the muscles. If desired, add highlights to the top of the knee and the peak of the shin.

Skin tones

Side
Foot

Drawing feet doesn't have to be difficult. To draw this side view,
all you need are two triangles and to follow these simple steps.

(1) Draw two triangles,
as shown.

(2) Add a circle at the top
and a squashed oval at
the bottom left. Add
two vertical lines
coming out from the
circle, as shown.

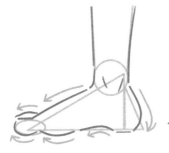

(3) Draw a rough sketch with more fluid lines.
Round the heel and add an arch to the
bottom of the foot. Add a little line over
the big toe for the other toes.

(4) Ink your lines, adding a couple
more lines for the ankle bone and
a simple line for the toenail.

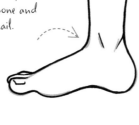

(5) Color the foot and
shade it to finish.

Skin tones

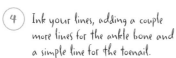
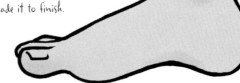

Foot

Try drawing feet from a front view. This will help you
to perfect your standing characters.

1 Draw an isosceles triangle. Add a circle to the top for the ankle.

2 Add two almost-vertical lines coming from the circle. Add two squashed ovals to the bottom of the triangle: one small but rounder and the other wider but flatter.

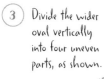

3 Divide the wider oval vertically into four uneven parts, as shown.

4 Draw a rough sketch with more fluid lines, referring to the arrows.

81

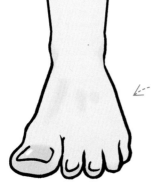

5 Ink your lines. Erase the guidelines, and then add a simple line to show the toenails on the big toe and the two toes next to it.

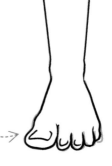

6 Color and shade the foot to finish.

Skin tones

Foot
Sneakers

Drawing your new footwear doesn't have to be difficult. Once you've perfected this, why not try varying the design?

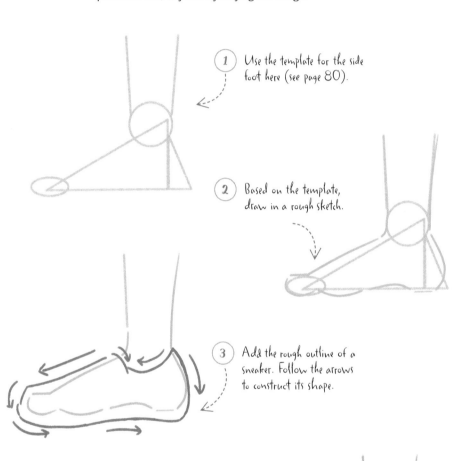

1. Use the template for the side foot here (see page 80).

2. Based on the template, draw in a rough sketch.

3. Add the rough outline of a sneaker. Follow the arrows to construct its shape.

Note:
Each type of shoe has its own distinctive shape and features — observe these before drawing. Even though the drawing is simple, if all the significant features are there, the shoe type will be instantly recognizable.

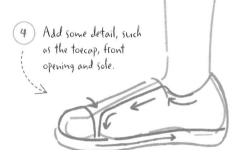

4. Add some detail, such as the toecap, front opening and sole.

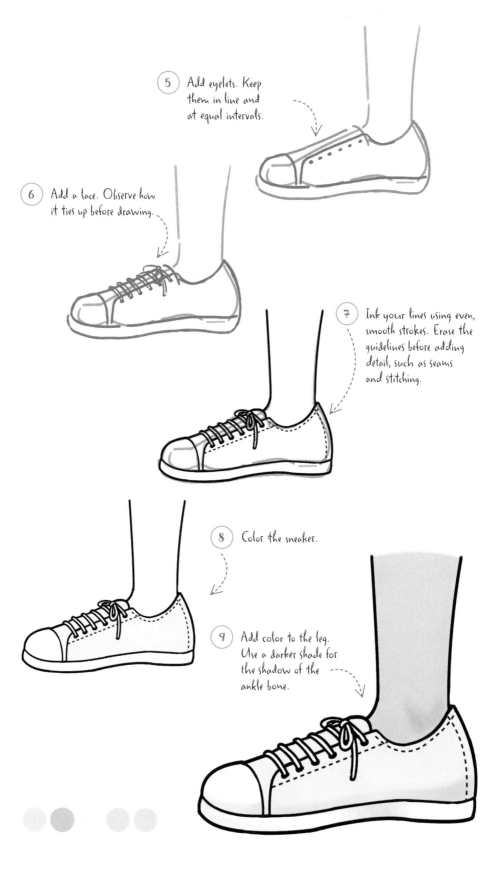

5. Add eyelets. Keep them in line and at equal intervals.

6. Add a lace. Observe how it ties up before drawing.

7. Ink your lines using even, smooth strokes. Erase the guidelines before adding detail, such as seams and stitching.

8. Color the sneaker.

9. Add color to the leg. Use a darker shade for the shadow of the ankle bone.

83

Foot
Heels

Add some glamour to your character by giving
them some bright-pink heels.

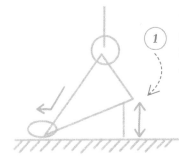

1 Use the template for the side foot
here (see page 80), but in this case,
draw it at an angle, as shown.

2 Based on the
template, draw
a rough sketch.

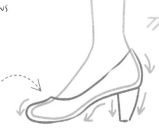

3 Add the rough outline of a shoe
with a heel. Follow the arrows
to construct its shape.

4 Ink your lines, using
even, smooth strokes.
Add detail such as
the sole.

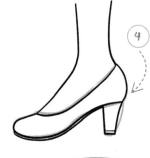

5 Add color to the shoe
and foot. Then shade
in the shadow of the
ankle bone.

Note:
When drawing shiny shoes, add
some crisp highlights with
a white opaque pen.

Foot
Boots

Try adding boots to your character's outfit
for a more casual look.

1 Use the template for the side foot here
(see page 80), but in this case, leave
some space between the foot and the
ground, and draw the foot at a
slight angle, with the toe area bent
up, as shown.

2 Based on the
template, draw
a rough sketch.

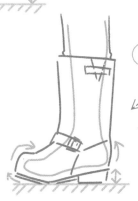

3 Add the rough outline of the boot,
following the arrows to construct
its shape. Boot toecaps will often be
angled slightly upward.

4 Ink your lines using even, smooth
strokes to convey the thick, hard
material. Erase the guidelines and
add details, such as soles, seams,
and buckles.

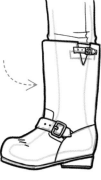

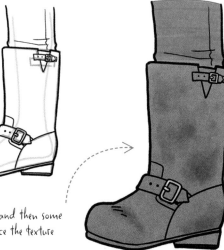

5 Add some color and then some
shading to enhance the texture
of the material.

Whole Body Poses

Standing
Female

This simple, standing female is perfect for your first complete figure. Add some long, flowing hair and give her some personality by adding a wave.

1 The common manga human figure is seven to eight heads tall. For simple standing poses, start with this template.

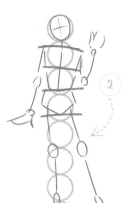

2 Draw a simple bone structure with joints. Check the angles and heights of the parts, such as the height of each shoulder and the position of each foot.

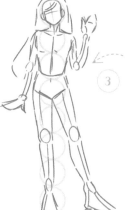

3 Add some volume to fill out the body, considering the body type you are drawing; in this case, a tall, medium-built figure.

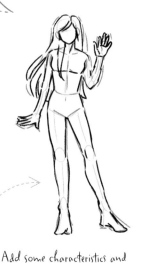

4 Add some characteristics and details. Shape the body into a female form by using soft lines. Consider the hairstyle.

5 Dress your female and add some details. Check the balance before inking. Think about the material and the shape of each garment.

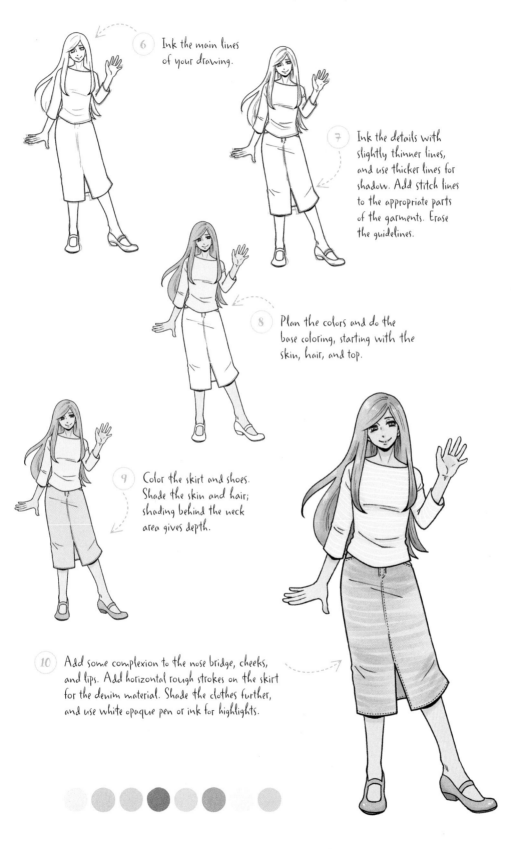

6 Ink the main lines of your drawing.

7 Ink the details with slightly thinner lines, and use thicker lines for shadow. Add stitch lines to the appropriate parts of the garments. Erase the guidelines.

8 Plan the colors and do the base coloring, starting with the skin, hair, and top.

9 Color the skirt and shoes. Shade the skin and hair; shading behind the neck area gives depth.

10 Add some complexion to the nose bridge, cheeks, and lips. Add horizontal rough strokes on the skirt for the denim material. Shade the clothes further, and use white opaque pen or ink for highlights.

Standing
Male

Take all the aspects you've learned so far and put them together. Add some attitude by using a cool expression and placing a hand on the hip.

1. The common manga human figure is seven to eight heads tall. For simple standing poses, start with this template.

2. Draw a simple bone structure with joints. Check the angles and heights of the parts, such as the height of each shoulder and the position of each foot.

3. Add volume to fill out the body, considering the body type you are drawing; in this case, a sporty, well-built figure.

4. Add some characteristics and details. Consider the hairstyle and facial expression.

5. Dress your figure, adding some details. Check the balance again before inking.

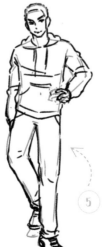

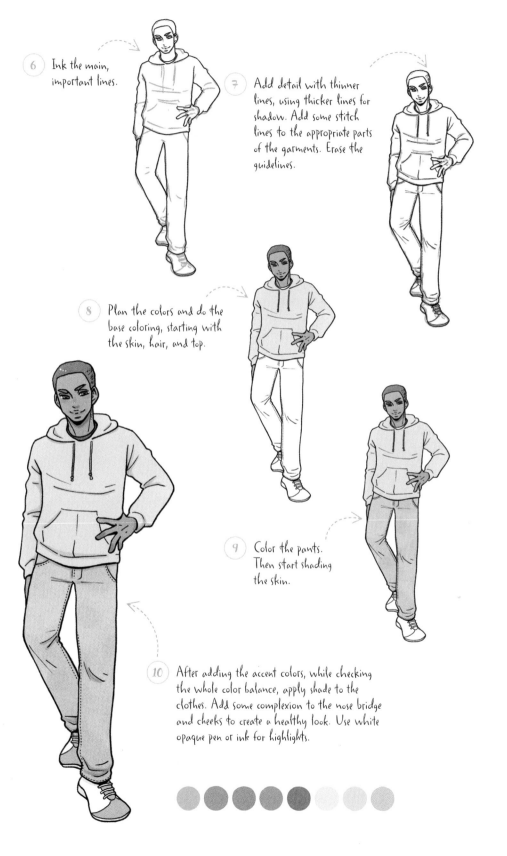

6 Ink the main, important lines.

7 Add detail with thinner lines, using thicker lines for shadow. Add some stitch lines to the appropriate parts of the garments. Erase the guidelines.

8 Plan the colors and do the base coloring, starting with the skin, hair, and top.

9 Color the pants. Then start shading the skin.

10 After adding the accent colors, while checking the whole color balance, apply shade to the clothes. Add some complexion to the nose bridge and cheeks to create a healthy look. Use white opaque pen or ink for highlights.

Standing
Chibi

You can draw this cute character by using two circles as a guide.
Combine the cute eyes with simple facial features.

1. Draw two circles and add a slanted vertical line in each.

2. Draw a rough bone structure within the circles.

3. Add some volume to the body, keeping it simple.

4. Add the rough idea of the outfit. Consider each garment's significant shapes and silhouette. Also add the facial features.

5. Add more detail. Plan decorative costumes and accessories well before inking.

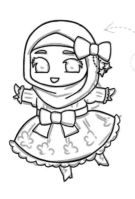

6 Ink the main lines, using smooth and simple strokes.

7 Ink the detail: keep it simple and add only significant creases. Erase the guidelines.

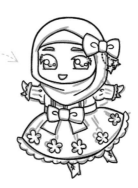

8 Use the color scheme below to add the base colors, starting with the face, hijab, and dress.

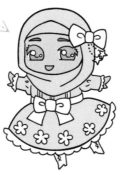

9 Color all the accessories and details, while considering the whole color balance.

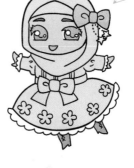

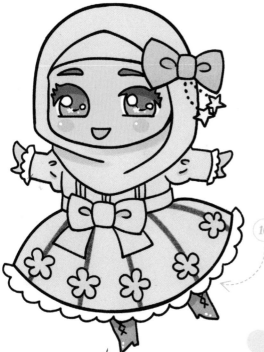

10 Add stripes to the dress and some shading, but do not overdo it. Round the cheeks. Use white or pastel opaque pen or ink for highlights and the fancy stars in her eyes.

Sitting
Female

This seated position is more relaxed and natural than
a standing pose, but can be drawn just as easily.

1. Create a rough plan with a simple bone-structure model. Keep that eight-heads-tall model in mind and check the balance from time to time.

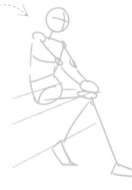

2. Check the angles and heights of the parts, such as the height of each shoulder and the position of each foot, by using the lines shown.

3. Add volume to fill out the body, while considering the body type you are drawing; in this case, a medium-built figure.

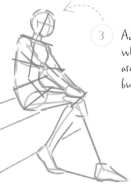

4. Add some characteristics and details. When you draw something you have not drawn before, do some research and familiarize yourself with the shapes and workings of the objects.

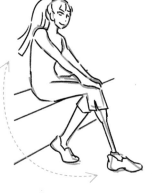

5. Dress your figure and add further detail. Check the balance again before inking. Think about the material and shape of each garment.

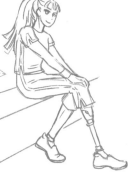

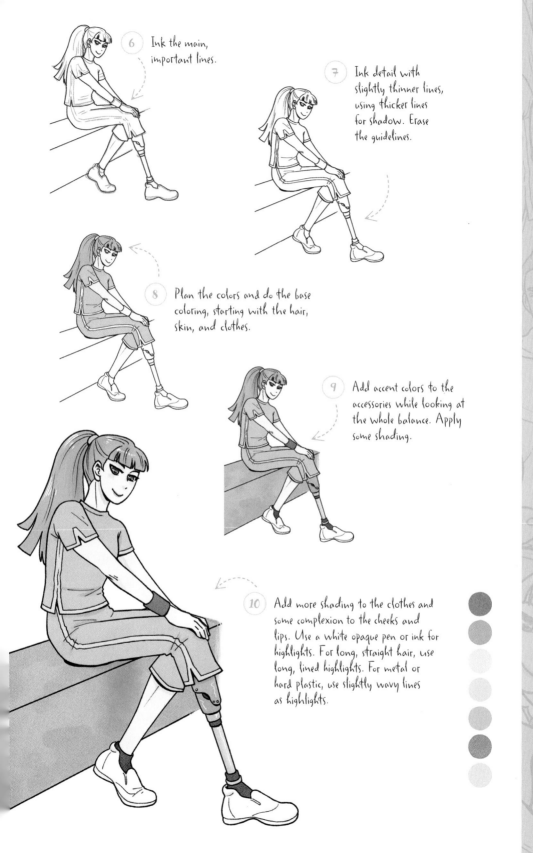

6 Ink the main, important lines.

7 Ink detail with slightly thinner lines, using thicker lines for shadow. Erase the guidelines.

8 Plan the colors and do the base coloring, starting with the hair, skin, and clothes.

9 Add accent colors to the accessories while looking at the whole balance. Apply some shading.

10 Add more shading to the clothes and some complexion to the cheeks and lips. Use a white opaque pen or ink for highlights. For long, straight hair, use long, lined highlights. For metal or hard plastic, use slightly wavy lines as highlights.

Sitting
Male

Separate the body into simple shapes to draw this relaxed, seated figure.

1 Create a rough plan of the model. Keep that eight-heads-tall model in mind and check the balance from time to time.

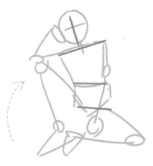

2 Check the angles and heights of the parts, such as the height of each shoulder and the position of each foot, by using the lines shown.

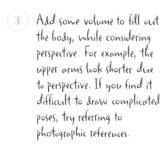

3 Add some volume to fill out the body, while considering perspective. For example, the upper arms look shorter due to perspective. If you find it difficult to draw complicated poses, try referring to photographic references.

4 Add some characteristics and details. Consider the hairstyle, and keep checking the whole balance.

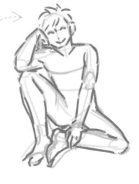

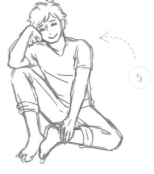

5 Dress your figure, adding some details. Check the balance again before inking. Consider the material and shape of each garment.

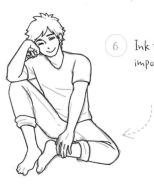

6 Ink the main, important lines.

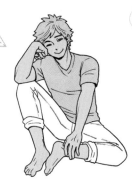

7 Add detail with thinner lines, using thicker lines for shadow. Add stitch lines to the appropriate parts of the garments. Erase the guidelines.

8 Plan the colors and do the base coloring, starting with the skin, hair, and top.

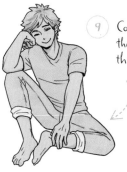

9 Color the pants, and then start shading the skin.

10 Add complexion to the nose bridge and cheeks to create a healthy look. Add horizontal rough strokes to the pants to create the denim material. Add shading to the clothes — a complicated pose means more shadowy areas. Use white opaque pen or ink for highlights.

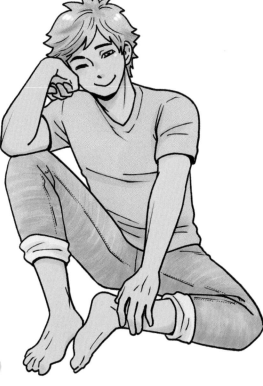

Sitting
Chibi

Give your cute characters personality by positioning them in their
favorite chair and giving them interesting accessories.

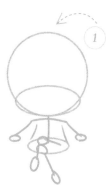

1 Start with the simple bone structure
to set the pose. Bearing in mind the
two-heads-tall chibi model, draw a circle
for the head and add an oval at
the bottom. Then add the body structure,
starting with the torso and hips, and
then the limbs — arms and crossed legs.

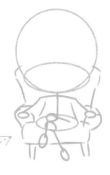

2 Roughly sketch the
armchair, making sure
the hips are on it.

3 Add some volume to
the body, and sketch
the facial features
and hair.

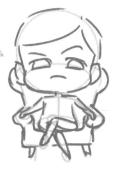

4 Dress your chibi and
define the shapes of
the chair.

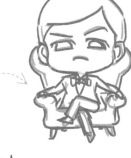

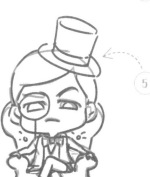

5 Add more characteristics and
details. It is always a good
idea to add the accessories at
the end, while checking the
whole balance.

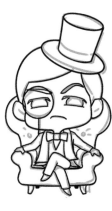

6 Ink the main lines, using smooth and steady strokes.

7 Add some detail with thinner lines. Erase the guidelines.

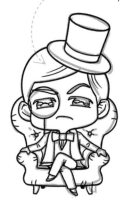

8 Color the base areas of your figure, using a light shade for the monocle to resemble the lens.

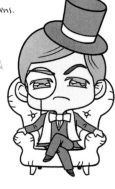

9 Add the accent colors. Check the whole color balance.

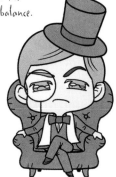

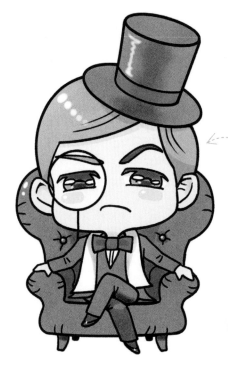

10 Shade where the body and chair would create shadow. Then use white opaque pen or ink for highlights.

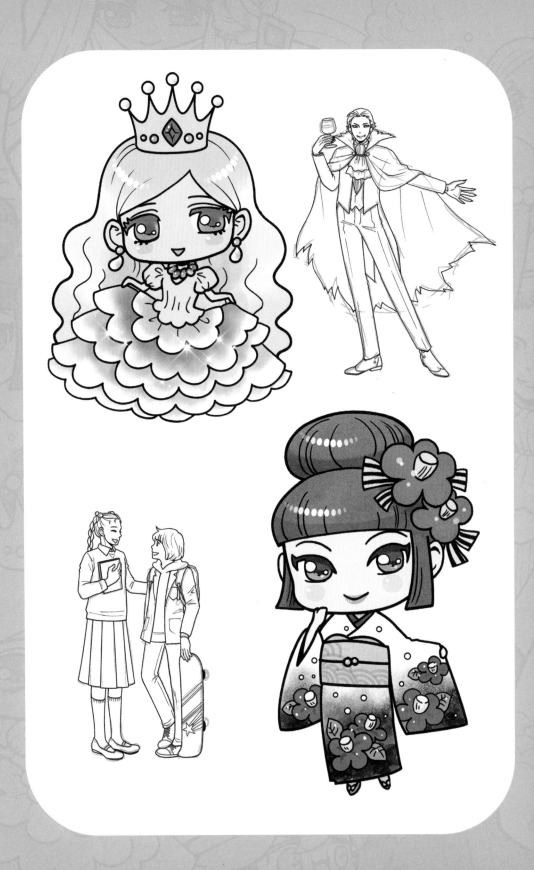

Characters

Manga
Mermaid

Take your manga creations to the next step with this magical mermaid.

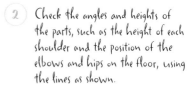

2 Check the angles and heights of the parts, such as the height of each shoulder and the position of the elbows and hips on the floor, using the lines as shown.

1 Make a rough plan of the pose. Bear in mind the eight-heads-tall template and check the balance. Consider the process of drawing the mermaid's fish tail, as if she has her legs inside a long, tight skirt.

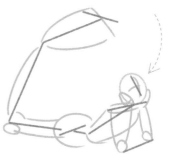

3 Add volume and fill out the body, while considering perspective. Keep checking the balance of the figure.

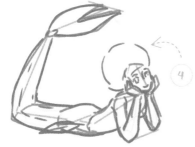

4 Add some characteristics and details. Consider the hairstyle.

5 Add more detail. If you are drawing a decorative outfit and accessories, plan them now, before inking. Refer to some photos of fish to observe the scales and shapes of fins.

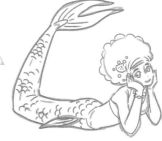

6 Ink the main, important lines.

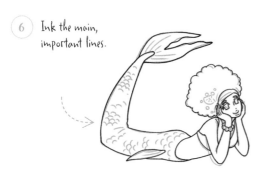
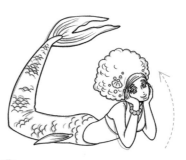

7 Add detail with thinner lines, using thicker lines for shadow, such as under the chin. Create texture for the hair and scales on selected areas. Erase the guidelines.

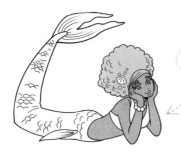

8 Plan the colors, and then color the face, hair, and body.

9 Color the rest using dabs of cute, soft, pastel colors on the tail to resemble iridescent scales.

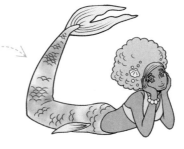

10 Add shading, and add complexion to the nose bridge, cheeks, and lips to create a healthy look. Use white opaque pen or ink to add highlights and sparkles.

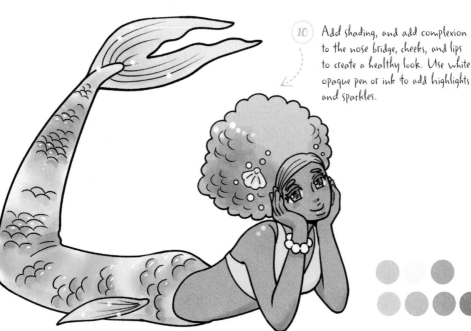

Manga
Vampire

Add a long cape and some fangs to your manga characters
to create your own creature of darkness.

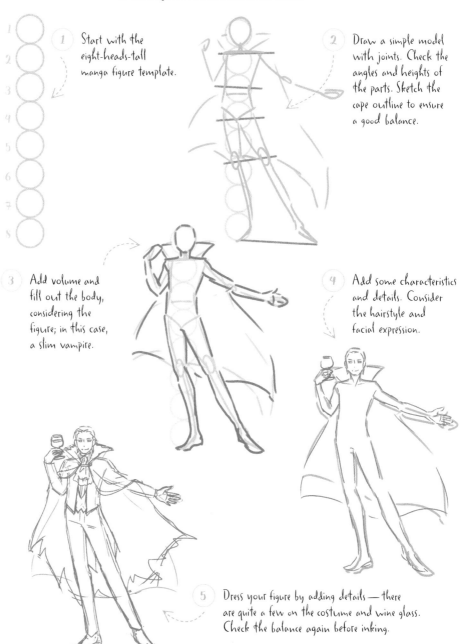

1 Start with the eight-heads-tall manga figure template.

2 Draw a simple model with joints. Check the angles and heights of the parts. Sketch the cape outline to ensure a good balance.

3 Add volume and fill out the body, considering the figure; in this case, a slim vampire.

4 Add some characteristics and details. Consider the hairstyle and facial expression.

5 Dress your figure by adding details — there are quite a few on the costume and wine glass. Check the balance again before inking.

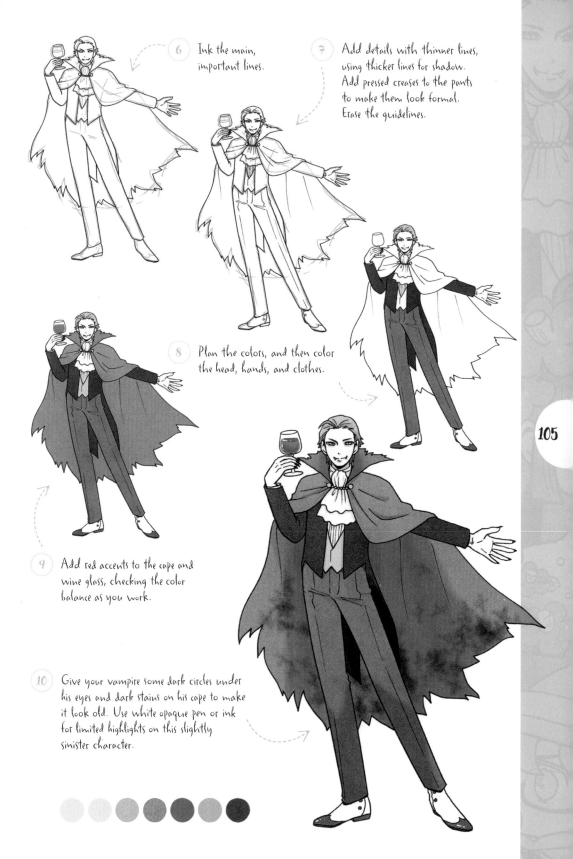

6 Ink the main, important lines.

7 Add details with thinner lines, using thicker lines for shadow. Add pressed creases to the pants to make them look formal. Erase the guidelines.

8 Plan the colors, and then color the head, hands, and clothes.

9 Add red accents to the cape and wine glass, checking the color balance as you work.

10 Give your vampire some dark circles under his eyes and dark stains on his cape to make it look old. Use white opaque pen or ink for limited highlights on this slightly sinister character.

Chibi
Princess

Draw a fairytale princess in just 10 simple steps.
Don't forget to add a golden crown and a beautiful gown.

1. Draw two same-size circles. Remember that a chibi-style character is two heads tall.

2. Add an oval to the bottom of the top circle to help construct the face. Then draw a rough bone structure within the bottom circle.

3. Add volume to the body and the big long dress. Sketch in the facial parts and the rough shape of the hair.

4. Sketch in the rest of the costume and accessories. Try to capture each garment's significant shape and silhouette.

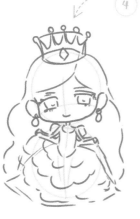

5. Add more details, planning them well before inking.

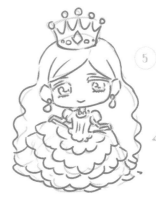

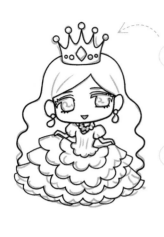

6 Ink the main lines, using smooth, simple strokes.

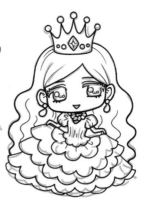

7 Add details with thinner lines. Erase the guidelines.

8 Plan the color scheme and start by coloring the face. Add a soft, candy-floss gradient to the hair by starting with pale tones and blending carefully.

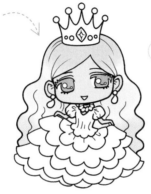

9 Color the other areas. Graduate the colors for the skirt by starting with the color of your choice and carefully diluting (with water if using watercolor, or blender if pen) and spreading it until it becomes translucent.

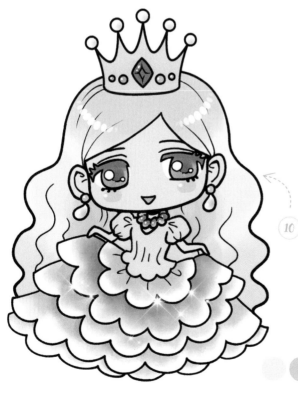

10 Add a pale, blue-gray gradient to the pearls on the crown and earrings. Add limited shading and some peachy cheeks. Finally, use white or pastel opaque pen or ink for highlights and sparkles.

Chibi
Prince

Play with fun accessories and styling for this chibi prince.

① Draw two same-size circles. Remember that the chibi style is two heads tall.

② Add an oval to the bottom of the top circle to construct the face. Then draw a rough bone structure in the bottom circle.

③ Add volume to the body, keeping it simple. Sketch in the facial parts.

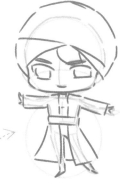

④ Sketch the costume. If you are designing costumes based on other cultures, do some research first. Try to capture each garment's significant shape and silhouette.

⑤ Add more details, planning well before inking.

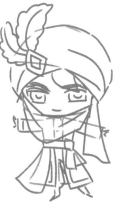

6. Ink the main lines, using smooth and simple strokes.

7. Add details, keeping the creases simple and trying to capture only the significant ones. Erase the guidelines.

8. Choose your color scheme and start with the face and turban.

9. Add more colors to the costume, referring to the regal color palette below.

10. Shade inside the eyes and some other areas. Add extra details such as the healthy round cheeks and the patterns on the garment. Use white or pastel opaque pen or ink for highlights and sparkles.

Manga
Schoolkids

Take what you've learned about drawing bodies and modify the
number of guide circles to draw two children of different heights.

1 For mid-teen characters, use this
seven-heads-tall template. This plan
is for two kids standing, one taller
than the other.

2 Considering the poses,
draw the simple models
with joints. Check that the
face angles resemble those of
chatting friends.

3 Add volume to fill out the bodies, while
considering the body types you are drawing;
in this case, one is a tall, skinny girl, the
other is a shorter, medium-built boy.

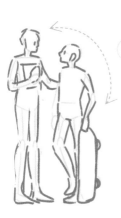

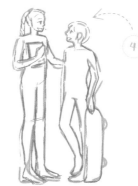

4 Add characteristics and
details. Shape the bodies into
human forms by using soft
lines. Consider the hairstyles
and props.

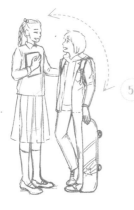

5 Dress your figures by adding further details. Consider the material
and the shape of each garment. Drawing two people together can
be challenging; check the balance of each individual and of the
composition as a whole. The characters should look connected.
Also check the look of the props. Does the skateboard look like
a skateboard? If not, refer to photographic references.

6 Ink the main, important lines.

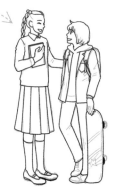

7 Add details with thinner lines, using thicker lines for shadow. Erase the guidelines.

8 Plan the colors and color the skin tones, hair and clothing.

9 Add all the accent colors for the accessories and details.

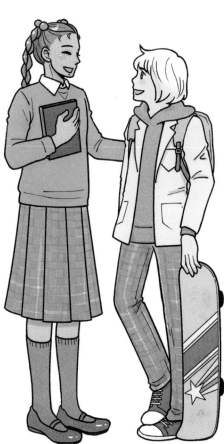

10 Add details such as the check pattern on the clothes. Give some shading, looking at the whole balance. Add complexion to the nose bridge and cheeks. Use white opaque pen or ink for highlights.

Chibi
Kimono

Try experimenting with cultural dress and accessories from some of your favorite places around the world.

1. Draw two same-size circles like this. Remember that a chibi is two heads tall.

2. Add an oval to the bottom of the top circle to construct the face. Then draw a rough bone structure in the bottom circle.

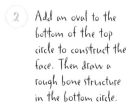

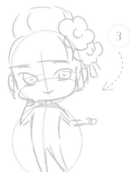

3. Add volume to the body, and sketch in the facial parts and rough style of the hair.

4. Sketch the costume; here, a traditional Japanese kimono. Try to capture each garment's significant shape and silhouette. When wearing a kimono, the left side is always on top of the right side.

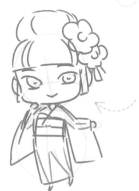

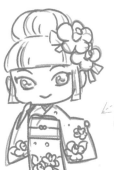

5. Add more details, planning them well before inking. For this image, the theme flower is a camellia. If you want to draw a certain flower, check how it looks before drawing.

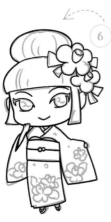

6 Ink the main lines, using smooth and simple strokes.

7 Add details with thinner lines. Erase the guidelines.

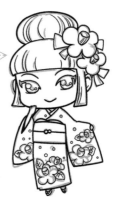

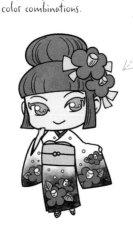

8 Add the base colors. For the kimono, start with the color of your choice (here, black) and carefully dilute (with water for watercolor, or blender for pens) and spread it until it becomes translucent.

9 Color the flowers and the accessories. If you need some inspiration, look up real kimono designs — they have a lot of unique yet traditional color combinations.

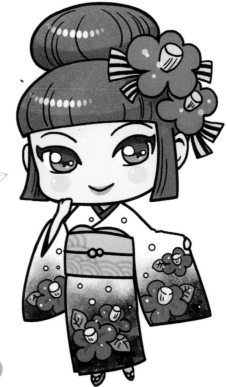

10 Add shading — see the illustration for how to add shade to the straight, smooth hair (at the base of the bun and bangs). Add some extra details such as rosy cheeks and lips. Finally, use white or pastel opaque pen or ink for highlights and sparkles.

Chibi
Wizard

Give your character magical powers with a wand,
wizard's hat, and a colorful cape.

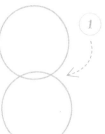

1) Draw two circles slightly overlapping each other.

2) To the top circle, add a vertical line curving to the right. Also add an oval, slightly right of the center. Draw a rough bone structure in the lower circle. This character is jumping in action, so curve the center of the body.

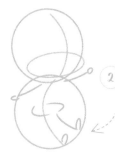

3) Add volume to the body and sketch in the facial parts.

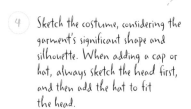

4) Sketch the costume, considering the garment's significant shape and silhouette. When adding a cap or hat, always sketch the head first, and then add the hat to fit the head.

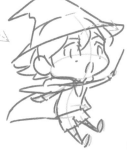

5) Add more details, planning decorative detail and accessories well before inking.

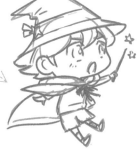

6 Ink the main lines, using smooth and simple strokes.

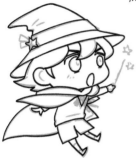

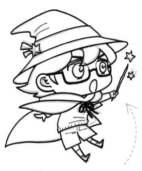

7 Add details, including the glasses. (I decided to add the glasses last-minute; do this whenever you feel it is needed, but always check the balance and details.) Erase the guidelines.

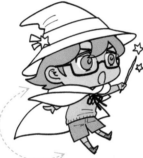

8 Choose your color scheme and start with the face, hair, and basic clothes.

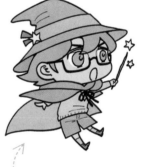

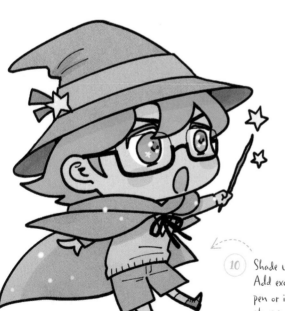

9 Color the rest of the image, while checking the whole balance.

10 Shade under the hat brim and inside the cape. Add excited, rosy cheeks. Use white or pastel opaque pen or ink for highlights, and add magical stars in his eyes to finish.

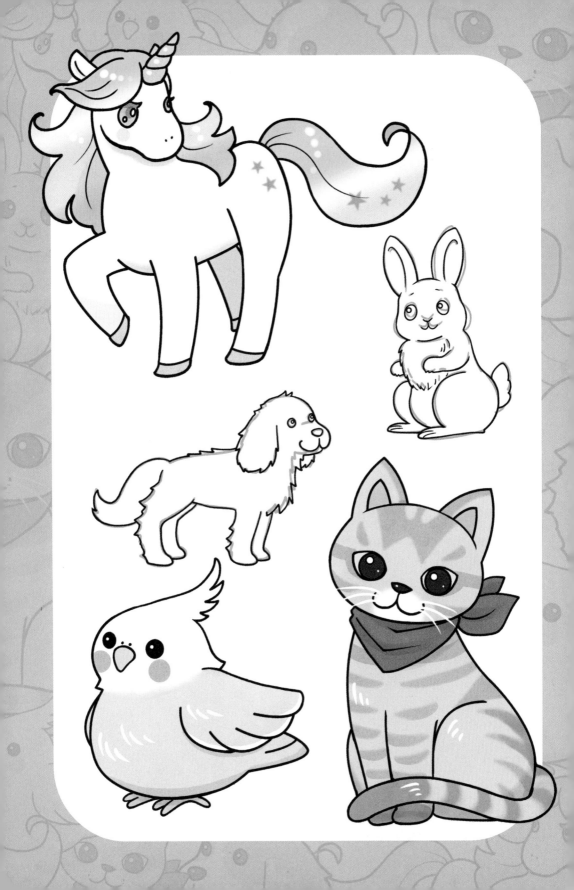

Manga
Animals

Cat

Use triangles and circles to draw the perfect feline
friend for your manga characters.

1. Draw an angled oval for the head.

2. Add two triangles for the ears to the top of the oval and a trapezoid shape underneath.

3. Plan the detail. Draw a cross on the head, the horizontal line slightly lower than the center. Add an oval to the bottom right of the trapezoid. Draw three almost vertical lines for legs, and a curved line for the far back leg.

4. Use soft, curvy lines to form a cat shape. Sketch some details such as the facial parts and a tail, which is wrapped around its paws.

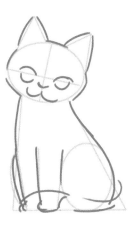

Note:
This cute manga cat does not have to be very realistic, but you should still use some significant forms to make sure that your drawing resembles the animal. For example, position the facial features lower than the center of the face.

5. Add more details.

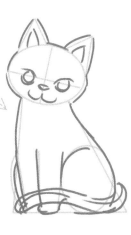

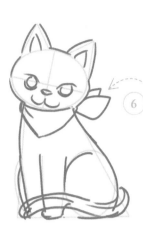

6. Complete the planning stage by adding a little extra detail; in this case, a cute scarf.

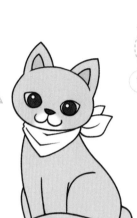

7. Ink your drawing, using smooth, soft lines. For a shaggy coat, use rougher lines. Erase the guidelines.

8. Add the base color of the body and eyes. Cats' eyes and fur have some unique color combinations — do some research for ideas.

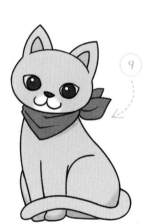

9. Add some shading and a base color for the scarf.

10. Add the fur pattern carefully. Use white opaque pen or ink for highlights on the eyes, nose, and whiskers, and some lines to enhance the fur's smoothness.

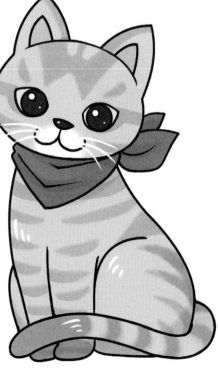

Dog

Dogs come in all shapes and sizes, so once you've perfected this pooch,
why not adapt the steps below to draw your favorite?

1 Draw a circle and an oval
overlapping each other for
the head and the muzzle.

2 Add a slightly smaller oval
as shown for the neck.

3 Add an irregular
square shape as
the arrows show.

Note:
For this cute manga
dog, choose some significant
forms to make sure that
your drawing resembles
the real thing.

4 Add the front and rear
leg shapes. Look at
photographic references
for a realistic shape.

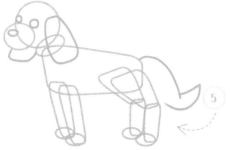

5 Complete the planning stage
by adding all four legs and
the other parts.

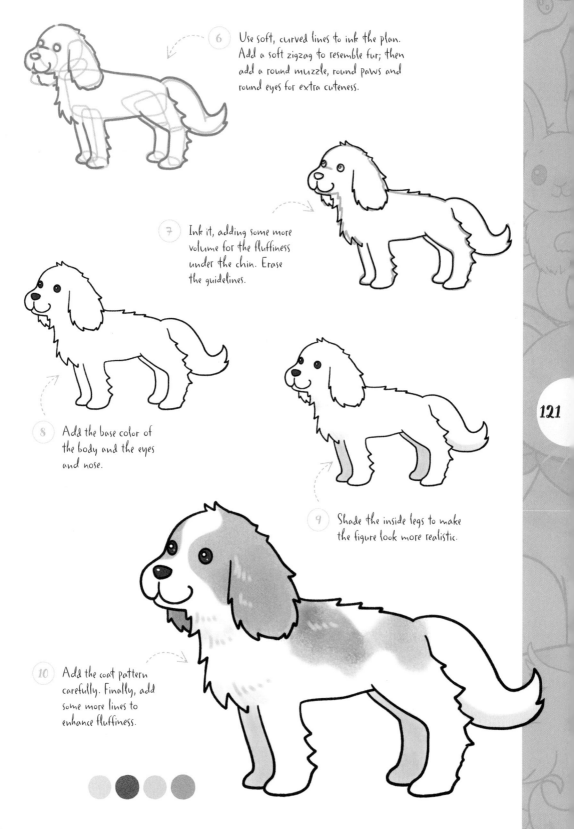

6 Use soft, curved lines to ink the plan. Add a soft zigzag to resemble fur; then add a round muzzle, round paws and round eyes for extra cuteness.

7 Ink it, adding some more volume for the fluffiness under the chin. Erase the guidelines.

8 Add the base color of the body and the eyes and nose.

9 Shade the inside legs to make the figure look more realistic.

10 Add the coat pattern carefully. Finally, add some more lines to enhance fluffiness.

Rabbit

Rabbits are known for their large ears and fluffy tails,
so make sure your cute bunny has these.

1. Draw two angled ovals,
the top one rounder than the
other, overlapping each other
as shown. They are going
to form the head.

2. Add two long leaf shapes
on top of the top oval
for the ears.

3. Add a slightly tilted
trapezoid shape
beneath the head.

4. Plan the detail. Draw an oval at
the bottom right of the trapezoid,
and a smaller oval on the other side.
Add squashed ovals at the bottom,
for the feet.

5. Sketch in more details: the eyes
(1), nose and mouth (2),
front legs (3), and tail (4).

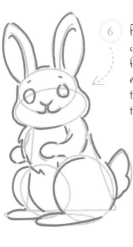

6 Follow the rough plan with soft, curved lines to shape a rabbit form. For this cute manga rabbit, exaggerate the size of the ears and tail, and add some extra fluffiness to the chest.

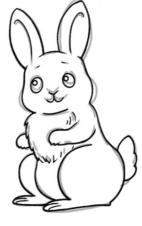

7 Ink your rabbit, using smooth, soft lines for the coat. Add some details with thinner lines, such as little slanting eyebrows. Erase the guidelines.

8 Add the base color of the body and the eyes. Sometimes you can ignore reality—I used soft pink for this rabbit to enhance its cuteness.

9 Add some shading, for depth.

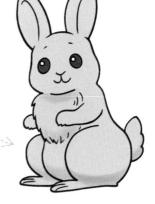

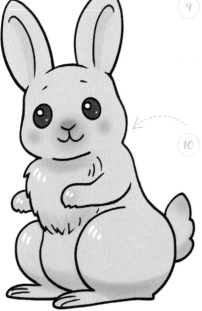

10 Darken the nose and add cheek color. Add some subtle pink shading inside the ears. Use white opaque pen or ink for highlights on the eyes and also some lines to enhance the coat's smoothness.

Cockatiel

Pay close attention to the wings and the crest
at the top of this small parrot's head.

1 Draw an oval and
add a curve to
divide it, as shown.

2 Add a bigger oval
under the first one,
slightly overlapping.

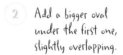

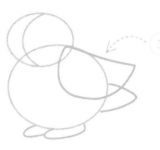

3 Plan the detail. Draw a
crescent shape for the wing,
a soft triangle shape for the
tail, and a couple of feet.

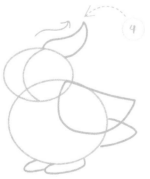

4 Add the most
important cockatiel
feature—the cute crest.
Refer to photographic
references to check the
shape.

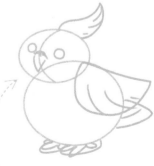

5 Sketch in the eyes, feet, and
beak. The cockatiel's beak has a
distinctive shape and tiny nostrils.

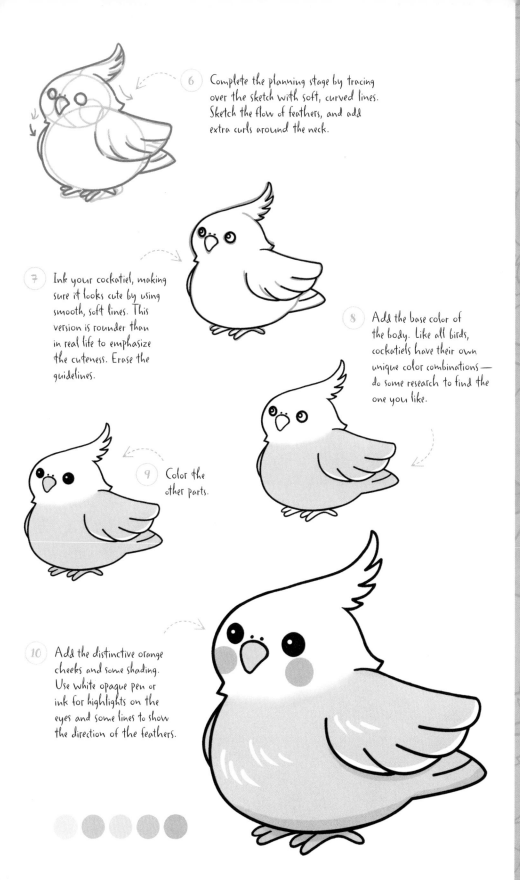

6. Complete the planning stage by tracing over the sketch with soft, curved lines. Sketch the flow of feathers, and add extra curls around the neck.

7. Ink your cockatiel, making sure it looks cute by using smooth, soft lines. This version is rounder than in real life to emphasize the cuteness. Erase the guidelines.

8. Add the base color of the body. Like all birds, cockatiels have their own unique color combinations — do some research to find the one you like.

9. Color the other parts.

10. Add the distinctive orange cheeks and some shading. Use white opaque pen or ink for highlights on the eyes and some lines to show the direction of the feathers.

Unicorn

This colorful unicorn is the ultimate manga pet. Use rectangles
and circles to help you correctly position the limbs.

1. Draw a circle and an
 angled oval overlapping
 each other, as shown.
 These will be the head
 and muzzle.

2. Add a slightly angled,
 rounded-off square
 overlapping the head area.
 Also add an irregular
 trapezium shape.
 These will be the
 neck and body.

3. Plan the front legs. Use four
 rounded-off rectangles, the upper
 ones thicker than the lower,
 and refer to the arrows for
 how to combine them.

4. Sketch the rear legs. Use three
 rounded-off rectangles, and
 refer to the arrows for how
 to combine them.

Note:
Even though this is
a cute manga-style unicorn,
refer to photos and pictures
of horses to make sure
that your drawing
resembles a horse.

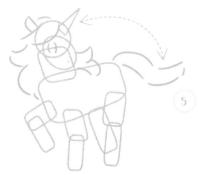

5. Add some other parts — most
 importantly, the horn. You
 can make its mane and tail
 dramatic and flowing.

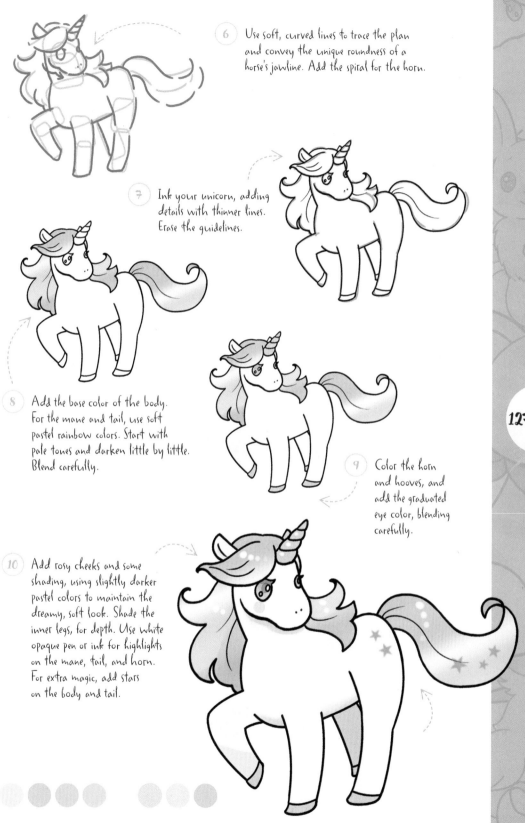

6 Use soft, curved lines to trace the plan and convey the unique roundness of a horse's jawline. Add the spiral for the horn.

7 Ink your unicorn, adding details with thinner lines. Erase the guidelines.

8 Add the base color of the body. For the mane and tail, use soft pastel rainbow colors. Start with pale tones and darken little by little. Blend carefully.

9 Color the horn and hooves, and add the graduated eye color, blending carefully.

10 Add rosy cheeks and some shading, using slightly darker pastel colors to maintain the dreamy, soft look. Shade the inner legs, for depth. Use white opaque pen or ink for highlights on the mane, tail, and horn. For extra magic, add stars on the body and tail.

About the Artist

Chie Kutsuwada is a UK-based Japanese manga creator and illustrator. She creates stories as well as illustrations, such as *King of a Miniature Garden* in *The Mammoth Book of Best New Manga II,* and *Moonlight* in *The Mammoth Book of Best New Manga III,* which was shortlisted in the Manga Jiman competition organized by the Japanese Embassy. She has also worked on Shakespeare's *As You Like It* and Musashi Miyamoto's *The Book of Five Rings,* and contributes to the ongoing bi-monthly illustrated column *Mondo Manga* for *Mainichi Weekly.* Chie also attends many manga-related events in and out of the UK and runs manga workshops at schools, libraries, and museums including The British Museum, The British Library, Wellcome Collection, and The Barbican. She has also worked on projects for Channel 4 and CNN.

If you'd like to find out more information or to see further examples of her work, you can visit her at: chitangarden.wix.com/chiekutsuwada, facebook.com/chitangarden, and on Twitter @chitanchitan.

Acknowledgments

A big thank you to my family in Japan. They fed me and supported me while I worked on this book, when I was visiting them over a festive season. And thanks to my housemate, who was patient with me when I was worried about the fast-approaching deadlines.

Also, I am very grateful to Abbie, Polly, and the team at The Bright Press. Thank you very much for this wonderful opportunity and for being supportive and patient with me!